ROSEMARY MAKHAN

FLORAL ABUNDANCE

APPLIQUÉ DESIGNS
INSPIRED BY WILLIAM MORRIS

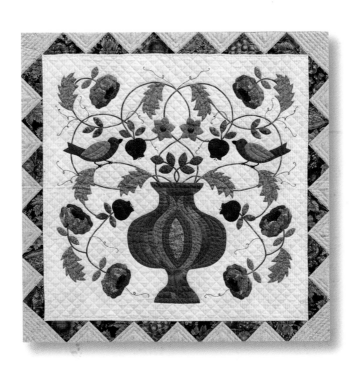

Martingale
& COMPANY

BOTHELL, WASHINGTON

CREDITS

President · Nancy J. Martin
CEO/Publisher · Daniel J. Martin
Associate Publisher · Jane Hamada
Editorial Director · Mary V. Green
Design and Production Manager · Stan Green
Technical Editor · Jane Townswick
Copy Editor · Lily Casura
Illustrator · Robin Strobel
Photographer · Brent Kane
Cover and Text Designer · Trina Stahl

That Patchwork Place is an imprint of Martingale & Company.

Floral Abundance: Appliqué Designs Inspired by William Morris
© 2000 by Rosemary Makhan

Martingale & Company
PO Box 118
Bothell, WA 98041-0118 USA
www.patchwork.com

Printed in China
05 04 03 02 01 00 6 5 4 3 2 1

The images on page 5 are reprinted from *William Morris: Designs and Patterns* by Norah Gillow, published by Bracken Books in 1988.

MISSION STATEMENT

We are dedicated to providing quality products and service by working together to inspire creativity and to enrich the lives we touch.

Libary of Congress Cataloging-in-Publication Data
Makhan, Rosemary.
 Floral abundance : projects in appliqué / Rosemary Makhan.
 p. cm.
 Includes bibliographical references.
 ISBN 1-56477-325-6
 1. Appliqué—Patterns. 2. Quilts. 3. Flowers in art. I. Title.
TT779.M2497 2000
746.46'041—dc21 00-061628

DEDICATION

To my family—Chris, Candice, and Kenneth. May we always be there for one another.

ACKNOWLEDGMENTS

This book could not have happened without the help of my wonderful students and friends. Many heartfelt thanks to all of you:

Patricia Christian, who encouraged me with her gift of my first reference books on William Morris;

Anne Gilmore, whose dedication and determination to finish her "Flowering Urn" four-block quilt astounded us all;

Karen L'Ami, who impressed me beyond belief with the speed of her workmanship on her Flowering Urn quilt blocks;

Janet Henry, whose enthusiasm was so encouraging, and whose willingness to share the "Flowering Urn" wall hanging with us is so appreciated;

Sheila Paprica, for her impeccable workmanship and dedication in getting her "Strawberry Season" wall hanging finished, in spite of all her other many commitments;

Betty Decent, Ruth Landon, Trudy Nicholls, Karen L'Ami, and Sheila Paprica for their willingness to help with the stitching of the "Springtime" wall hanging.

Ermy Akers and Susan Rankin, for their expert quilting;

Many thanks, too, to the number of other guild members who worked hard to get quilting done at the last minute: Cathy Cormier, Anne Gilmore, Joan Raynor, Teresa Kidd, Cathy Lamothe, Grace Maloney, Michelle Kranjc, Ruth Landon, Judy Garden, Carolyne Sparling, Vicki Grafham, Margaret Langlois, Diane Thurner and Jill Pettit.

Jane Townswick, whose careful editing helped to make this book what it is, and to Terry Martin and all those at Martingale & Company who gave their support, encouragement, and expertise in creating such an elegant book.

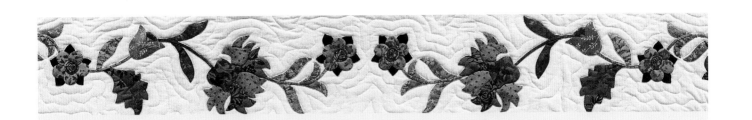

CONTENTS

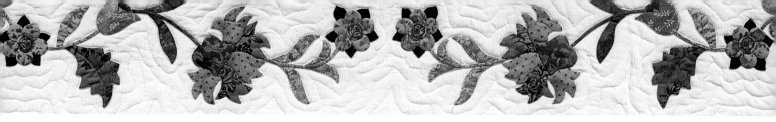

INTRODUCTION

IN HIGH SCHOOL, I hated studying history. Keeping track of dates, wars, and various timelines all happening in different countries at once overwhelmed me. When I decided to study interior design many years later for my own pleasure and interest, I was greatly surprised to find that I enjoyed the history courses most of all—history of furniture, history of textiles, art history, antiques. A whole new world had opened up to me, and I found myself gaining a real appreciation for the past.

A history-of-furniture course is where I first learned about William Morris. Morris started out as a painter, but his focus soon turned to woven tapestries, embroideries, rugs, furniture, stained glass, textiles, wallpaper, and elaborately printed books. There's even a "Morris chair" that bears his name—an upholstered chair with an adjustable back, one of the first reclining chairs ever made.

In a history of textiles course, I grew to appreciate and love Morris's work all the more. The beauty of his undulating, naturalistic designs for chintz fabrics and wallpapers both intrigued and fascinated me. One day, I decided, I'd make some quilts that used his unique designs for inspiration.

Morris's philosophy of art has had a great influence on my quiltmaking. He believed that good craftsmanship only grows from finding joy in your work, and that to create something beautiful with your hands, simply for the sheer pleasure of it, is one of the most satisfying things you can do. As a quilt artist, I could not agree more.

There are many talented people in this world—artists, writers, potters, sculptors, weavers—but few with the determination and work ethic of William Morris. In his short, sixty-two-year lifetime, Morris achieved more than most people could accomplish in several.

Born in 1834 to an affluent English family of Welsh descent, William Morris led a privileged life, thanks to his father's lucrative investments in copper mines. He attended a private boys' school and studied at Oxford University, graduating in 1855. He intended to become a priest and planned to establish a celibate, monastic community with of group of similarly idealistic university friends.

After traveling in Europe together, however, Morris and his friend Edward Burne-Jones became intrigued enough with medieval paintings and Gothic architecture to change their vocational aspirations. Morris chose architecture, and Burne-Jones began to study painting under the direction of Dante Gabriel Rossetti.

In 1859, Morris married Jane Burden, a stablehand's daughter, who exemplified the ideals of Pre-Raphaelite feminine beauty and had modeled for frescoes painted by Rossetti and his student, Burne-Jones. To celebrate his marriage, Morris commissioned an architect friend, Philip Webb, to design the Red House at Upton for his bride and himself. Unable to find furnishings that suited him, Morris and his friends decided to design and make their own. The firm they founded looked back to the Middle Ages for inspiration in craftsmanship, believing that period to be a time when artists were intimately involved in the production of their art—a far cry from

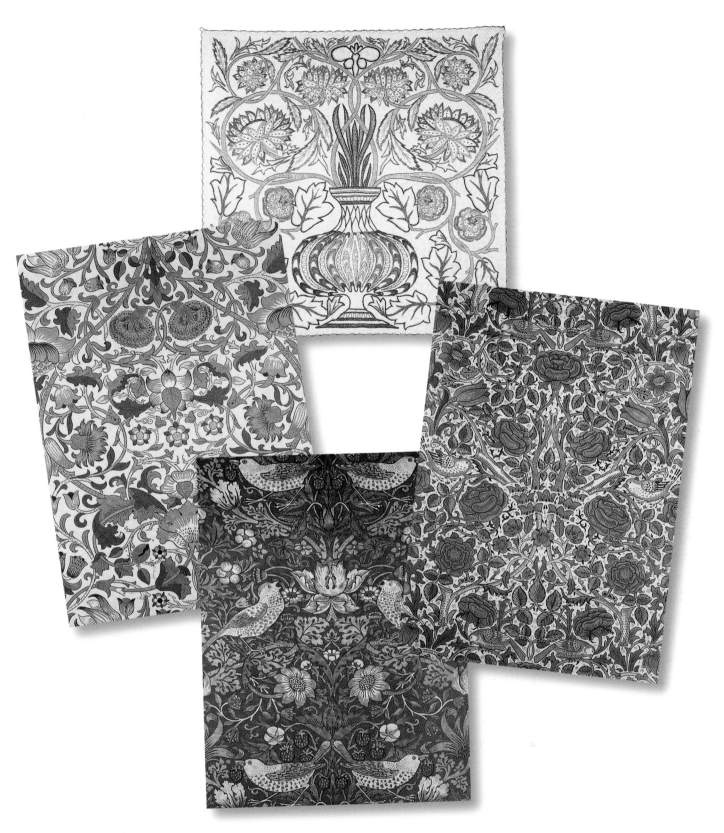

MORRIS'S TEXTILES, CLOCKWISE FROM TOP: *The Flowering Urn block was based on the Flower Pot Embroidered Cushion Cover, 1880. The bird and flower motifs used in the Flowering Urn block are from Rose Chintz, 1883. The "Strawberry Season" wall hanging was inspired by Strawberry Thief, 1883. The motifs used in the "Springtime" wall hanging came from Lodden Chintz, 1884.*

industrialized Victorian England, where craft had been lost in automation and few designers had much involvement in the production process.

Taking their cue from the writings of John Ruskin, who believed that quality and beauty could only be achieved by the labor of skilled artisans, Morris and his friends rebelled against increasingly impersonal production and started the influential Arts and Crafts movement, which influenced Frank Lloyd Wright and whose effects are still being felt today. Arts and crafts, Morris and his friends felt, when beautifully done, were every bit a valid form of art. This was novel thinking.

In his work, Morris advocated simplicity and moderation in household furnishings, believing, as one of the central themes of the movement emphasized, that you should have nothing in your home that you do not believe to be either useful or beautiful.

Eventually, textiles became the most popular items produced by Morris's company, and he designed most of the textiles and wallpaper himself. Nature was a great inspiration to Morris, and similarly, many of his ideas came from designs he'd seen on Medieval woven silks, Persian rugs, and Indian chintzes.

Morris's textiles were my inspiration for the five quilts in this book. The Flowering Urn block, which is used in three of the quilts, was based on The Flower Pot Embroidered Cushion Cover, which Morris's younger daughter, May, worked in silk and gold thread in 1880.

Morris's work, designs, and emphasis on the value of hand craftsmanship have had a profound influence on designers throughout the world. Thank you, William Morris, for your many great contributions to the world of textile arts.

—ROSEMARY MAKHAN

 # FABRIC CHOICES

IRST IMPRESSIONS COUNT! When you look at a quilt, the fabrics and colors are often deciding factors in whether or not you like the quilt. Choosing fabrics is a very important part in the planning of a quilt—a part that should be done thoughtfully and unhurriedly, with ease and enjoyment. For most of us, it is one of the most fun parts of quiltmaking. Just thinking about buying new fabrics makes me excited and anxious to get started!

MULTICOLORED FABRIC

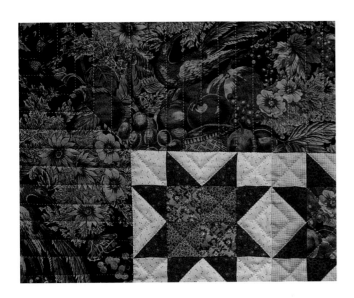

OFTEN, A PARTICULAR fabric that I really like starts me envisioning a quilt that I'd like to make. For example, I fell in love with the large-scale print in the border of the "Flowering Urn" medallion quilt, shown on page 34. That print is a drapery fabric that reminded me of William Morris's designs and colors, but since it is fairly lightweight, I decided it would work well for both the piecing and the border of my

quilt. It was a bit too heavy for the appliqué. I used the colors in this print to coordinate the other fabrics for my quilt, searching for as much variety in pattern, scale, and value as I could find. I purposefully mismatched some colors slightly, so that the finished quilt would have a bit of character to it, and not look like a manufactured bedspread or a kit. By the time I actually started making the quilt, I had accumulated a whole laundry basket full of wonderful fabrics!

CONTENT AND CARE

CHOOSE GOOD QUALITY, one hundred percent–cotton fabrics that are tightly woven. Take time to prewash and to set the colors—you'll be very glad you did. Prewashed fabrics are more flexible and easier to work with for appliqué.

BACKGROUNDS

THE BACKGROUND FABRIC of a quilt deserves special consideration. It should be in keeping with the overall feeling you wish to create in the quilt. I wanted my "Flowering Urn" medallion quilt to look like it might have been created during William Morris's lifetime, so I deliberately chose a mottled, tea-dyed fabric with an aged appearance. I also chose the patterns and colors of the other fabrics with this idea in mind. The medallion quilt was a popular style during Morris's time, so I thought that this type of setting would be appropriate for my quilt. Choosing a background color is important: White background fabrics can produce a crisp, fresh look in a quilt, while cream-colored or tan backgrounds can create a more

subtle, antique look. Dark backgrounds, as shown in the "Strawberry Season" wall hanging on page 54, can also be dramatic.

APPLIQUÉ FABRICS

THE COLOR(S) YOU choose for your background fabric will help, in turn, to determine the choices you make for the appliqués in your quilt. Use these guidelines for choosing appliqué fabrics that will help create a dynamic color palette for your quilt.

 TIP: *Tone-on-tone prints, indistinct patterns, and shaded fabrics will create more realism in appliqué than busy prints.*

The Importance of Value

The lightness or darkness of a color is called its value. An appliqué design should stand out from the background, not blend in, so it's important to choose appliqué fabrics with a certain degree of contrast. To do this, include a wide range of values in your appliqué fabrics. For example, medium and dark values look great on light background fabrics, while light and medium values work well on dark backgrounds. Clear, bright colors, rather than grayed or dull colors, look best on dark backgrounds.

You can make an appliqué flower look more realistic by varying the values in the petals themselves. As a general rule, flowers are usually darkest in value at their centers, where the petals are massed closer together. Values lighten progressively toward the edges, because of the way the petals spread out and because of the way light shines on the flower. I often trace freezer paper shapes for a shaded flower and

 TIP: *Hand-dyed fabrics are wonderful for creating realistic-looking flowers, as you can often get several different values from the same piece of fabric.*

Shaded fabrics and prints that feature flowers and leaves are great for adding a feeling of dimension in leaves. Sometimes I cut leaf motifs from this type of fabric and appliqué them, in broderie perse style, to create visual texture in a quilt. I also like to cut the center from a printed flower motif, such as the example below left, which I stitched at the center of the small flower in my "Flowering Urn" medallion quilt (below right).

Floral print with motif removed

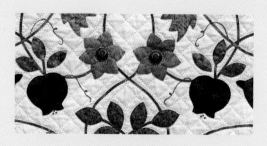

Motif used in finished quilt

press them onto the fabrics, so that I can cut them out and glue them onto a piece of paper to make a mock-up of the flower. Then I pin or glue this flower in place on the block and put it up on my design wall. I often find that I need to change some of the fabrics, because at a distance, the values need to be more varied than they looked up close. Sometimes fabrics even need to be slightly mismatched to create the effect of dimension.

Similar values blend when seen from a distance (above left). To keep different appliqué pieces distinct, vary fabric values, as shown here (above right).

Yardages

For the appliqués in this book, collect a lot of fat quarters, as larger amounts of fabric are usually not necessary. An array of small pieces of fabric allows you to act as an artist with a paint set—you can experiment and play with different fabrics until you achieve the look you like. Leaves and stems can take a bit more fabric than other appliqué pieces, because they are cut on the bias, so collect fat quarters or half yards of fabric for those pieces, depending on the intended size of your quilt.

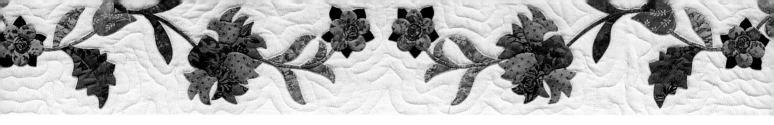

FREEZER PAPER APPLIQUÉ

PREPARING BACKGROUND BLOCKS AND BORDERS

To MAKE COMPLETE master patterns for the blocks and borders in this book, photocopy the pages indicated in each project and tape the pages together as shown in the template placement diagrams.

To cut the background blocks and borders for your quilt, you can follow the dimensions given in each project; or, if you have enough fabric, you can cut the blocks and borders ½" larger than necessary. That way, you can trim them to the correct size after your appliqué is complete. (Background fabric can shrink slightly or fray during the stitching process.)

To establish the center of each block so you can position the appliqués correctly, carefully fold each background block in half and then fold it once more, into quarters. Crease the folds lightly with your fingers to establish the centering lines. Place the block pattern underneath your background block so that the creases are positioned directly over the center lines on the pattern. Pin the background block in place so it will be easy to mark the fabric.

Establish the center of each border strip by folding the strip in half lengthwise and creasing the center fold.

Working from your master patterns and using a good fabric-marking pencil, lightly trace the following lines onto the background fabric for both blocks and borders: tendrils, a single line for each stem, and a minimum number of other lines to act as placement

guides for the appliqué shapes. It is not necessary to trace whole appliqué shapes onto the background fabric. If you cannot see through your background fabric, use a light table, or trace the design at a window. You can also put dressmaker's carbon or graphite paper under the pattern and trace over the lines with a stylus or the point of a dried-out ballpoint pen, so that the pattern lines transfer easily onto your background fabric.

MAKING TEMPLATES

OF ALL THE methods of appliqué I have tried, the one I like the best is using freezer paper templates inside the appliqué shapes. Freezer paper appliqué is very easy to do, and with a little practice, it produces perfectly formed appliqué shapes. It also eliminates the need for doing a fabric mockup to preview your design, because you can see immediately what your finished appliqué shapes are going to look like and make fabric changes before you start stitching, which helps avoid the aggravation of having to remove appliqué stitches later.

For freezer paper appliqué, you will need to trace and cut out freezer paper templates as directed on the project's template patterns. Follow the directions written on your pattern; for example, "Pomegranate Leaf/Make 18." Take care to trace accurately on the dull side of the paper and to cut smoothly, because the shapes and sizes of your templates will be exactly the same as your finished appliqués.

For appliqué shapes that need to be reversed, trace the pattern piece onto the dull side of a piece of freezer paper. Then staple another piece of freezer paper to it, with the shiny sides facing each other, taking care not to staple the interior of the traced shape. Cut both appliqué shapes at the same time to produce one regular and one reversed appliqué shape. This step will cut both your tracing and your cutting time in half, and it means that your quilt will be finished that much faster.

Write the identifying letters from the patterns on the dull side of your freezer paper templates, so that you can see at a glance how each appliqué shape fits into the block design. Also, note that any edges that will tuck under another shape are marked with a small **v** on the patterns in this book. Be sure that you include these marks on your freezer paper templates, so that you will remember not to turn under the seam allowances on those edges. You can achieve a smoother join between appliqué shapes if the underlying edges lie flat under the pieces that are positioned on top of them.

PREPARING
APPLIQUÉ SHAPES

PRESS YOUR FREEZER paper templates, shiny side down, onto the wrong side of your appliqué fabrics, using a dry iron on the cotton setting. Be sure to

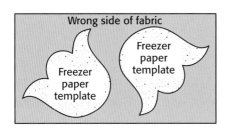

leave ½" between the freezer paper templates, to allow for cutting the seam allowances between the appliqué shapes. Whenever possible, place appliqué shapes so that the edges are positioned on the bias of the fabric, because bias seam allowances will fray less, and they are easier to turn over the curved edges of a freezer paper template.

Letting your eye be your guide, cut around the freezer paper templates, leaving a scant ¼" to $^3/_{16}$" seam allowance.

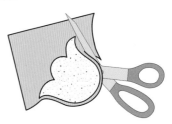

Clip the seam allowance only where necessary—usually at indentations on an appliqué shape, such as on the top edge of a tulip. Excessive clipping will weaken a seam allowance, making it more difficult to turn a smooth edge on the appliqué shape. Using a water-soluble fabric gluestick, put some glue around the outside edge of the freezer paper template, except on edges that will tuck under another shape. Using a rolling motion, finger-press the fabric seam allowance all the way around the glued edges of the freezer paper to create a nice, smooth edge with no puckers or points.

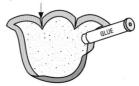

Clip inside corners.

To create a point on an appliqué shape, first fold and glue the fabric over the freezer paper template along one side of the shape, as shown. Then do the same along the other side.

If the point is very sharp, such as on the tip of a leaf, there may be a little flap that sticks out. Trim this flap slightly and fold it straight across (and down) behind the point. You can tuck any excess seam allowance under with the needle when you appliqué the shape onto the background block.

PREPARING NARROW BIAS STEMS

WONDERFULLY FINE BIAS stems are amazingly simple to make. Although they look difficult, they are actually quite easy—unlike most things in life, where the opposite is true! All of the bias stems in *Floral Abundance* projects finish ⅛" wide.

Start by cutting several ½"-wide bias strips from your green fabrics. As you are cutting each bias strip, the edge of the fabric should just be barely visible along the outside edge of the ½" ruler markings. To estimate how many bias strips you will need for your project, lay some lengths of cut bias strips down roughly over the drawn stems on the pattern you have selected.

Lightly spray the bias strips with spray sizing, a product that is similar to spray starch but not as heavy. Spray the bias strips until they are slightly damp, but not wet. I like to put about four bias strips at a time into a small plastic bag and spray them at the same time, gently moving the strips around until they are evenly coated with spray sizing.

Using a Clover ¼" (6 mm) bias tape maker (the only brand that works well for this technique), insert the diagonal tip of one bias strip into the wide end of the tape maker. The right side of the fabric should be facing up, so that you can see it through the slot on top of the tape maker. Use a long straight pin to coax the bias fabric strip through the tape maker until it starts to come out the small end. Keep the bias strip centered as it goes into the wide end of the bias tape maker and make sure that the cut edges of the folded bias strip meet at the center when the strip is pressed. Pull the tape maker slowly, while pressing the folded bias strip with a hot steam iron set on the cotton setting. Be careful not to stretch the bias strip, and use the side of the iron, keeping it as close as possible to the tape maker.

Edges just meet on wrong side.

When you need narrower bias stems for a project, use a water-soluble fabric gluestick to put a small amount of glue along the wrong side of the pressed bias strip (the side with the raw edges). Fold the bias strip in half, so that it will finish 1/8" wide when stitched, and press it with a hot steam iron set on the cotton setting. Keep one edge slightly lower than the other, and make this lower edge the wrong side of the bias stem.

Glue and fold to ⅛".

POSITIONING THE APPLIQUÉS

POSITION AND GLUE-baste the prepared bias stems and appliqué shapes onto the marked background fabric. Use the pattern as a guide to which shapes and stems to place first. Use the gluestick sparingly, and try to avoid putting any glue at the center of each shape. Place the folded edge of bias stems along inside curves, being careful not to stretch the stems. Try to ease a little extra fullness into the curves. Leave a full ¼" or more at each end of each stem for tucking under other appliqué shapes, as stems often shrink slightly when stitched.

You may find it easiest to sew a block or border in sections, stitching in only one area at a time. For example, you can assemble a complete layered flower before stitching it onto the background fabric. If you do decide to sew one section of a block at a time, be very careful that everything is lined up correctly so that there will be no awkward spaces or overlapping areas when you are finished stitching.

STITCHING THE APPLIQUÉS

SEW THE APPLIQUÉ shapes in place on the background block with closely matching thread, a #10 or #12 appliqué needle, and a thimble on the middle finger of your sewing hand. Cut a strand of thread no longer than 18" to prevent knotting and tangling. Cut the end at a slight angle, if you can, to make threading the needle easier. Place your starting knot just inside a marked appliqué shape, on the wrong side of the fabric.

I prefer to stitch toward myself, working in a clockwise direction, so that the edge I am sewing is always closest to me. That way, I can see exactly where to take each stitch. However you like to hold your work, be sure to take small stitches that catch the edge of the appliqué shape and then go directly down into the background fabric. Each stitch should be straight, with no "traveling" on the right side of the fabric, which creates slanted or angled stitches.

Needle is parallel to edge of fabric.

Appliqué stitches should be invisible on the right side of your work and ⅛" apart (or less) on the wrong side. As you take each stitch, pull the thread fairly tight, so the stitch will sink down into the fabric, but not so tight that your stitches make the fabric pucker. Take extra stitches at the ends of points and at indentations where there is not much seam allowance. Always

Take extra stitches at inner and outer points.

stitch the inside edge of a bias-stem curve first, to prevent puckers. To end a row of stitches, use either a knot or three little stitches inside the appliqué shape on the wrong side of your work.

Stitching Sequences

As you stitch the blocks in this book, you will notice that it is usually easier to sew the outer parts of a pattern first. After these portions of a block are securely attached, you can reach over them easily and sew the interior shapes without causing them to shift.

When you stitch one appliqué shape on top of another, try to sew only to the fabric that lies directly

beneath the top shape, rather than going through all of the layers to the background fabric. To start stitching two shapes together, make sure that the knot in your thread lies underneath the shapes. End the thread on the right side of your work by taking a backstitch and then running the thread along the edge of the appliqué shape for a short distance; repeat this process several times before cutting the thread.

REMOVING THE FREEZER PAPER

AFTER YOU FINISH stitching all of the appliqués for a block, remove the freezer paper templates. Carefully make a slit behind each appliqué shape, using either a small, sharp pair of scissors or the tip of a seam ripper.

Then soak the block for about five minutes in lukewarm water to which a little white vinegar has been added to remove the water-soluble glue. Do not soak the block for too long, or the freezer paper will become soggy. Reach in through the slit behind each appliqué shape and remove the freezer paper gently. Where one appliqué shape lies on top of another, remove the paper from the underlying layer first; then make a slit in the next layer and remove that freezer paper. Continue until all the layers of freezer paper are removed. Then rinse the block to remove all traces of glue. Roll the block in a towel to remove excess moisture.

TIP: *Use a pair of tweezers or a long pin to force the freezer paper up inside an appliqué shape so that you can pull it out more easily. This works especially well for small appliqué shapes.*

Finally, press the finished block while it is still slightly damp, working first on the wrong side, and then on the right side. Trim away the background fabric behind large appliqué shapes, leaving only a ¼" seam allowance. This will reduce bulk and make the shapes easier to quilt.

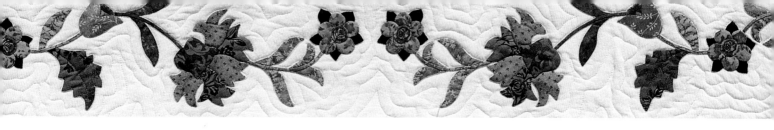

EMBROIDERY STITCHES

For THE TENDRILS, use the stem, or outline, stitch. Thread an embroidery needle with two strands of embroidery floss. Work from left to right, bringing the needle up through to the front of the fabric along the marked line. Take a small stitch along the line and draw the needle through, as shown, leaving a tail of floss to weave in later on the wrong side of your work. Keep your stitches a uniform length, and angle them slightly along the marked line. Keep the thread consistently either above or below the line, whichever is more convenient for you. End your line of stitches by weaving the end of the thread through the stitches on the wrong side of your work.

Stem Stitch

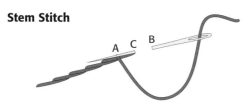

The threads are picked up at a slight angle to the line.

Several rows of stem (outline) stitch worked closely together can also be used to make a bird's legs and claws. You can make pointed claws by sewing two rows of stem stitch; make the second row start one half-stitch shorter than the first row.

Pointed end →

For the pomegranate seeds, use French knots. Thread an embroidery needle with two strands of embroidery floss in a color to match the pomegranate. Bring the floss through to the front and wrap it around the needle three times, as shown (A). Pull the needle through the wrapped thread, keeping your thumb on the wrapped area so that it will not become loose. Insert the needle back down into the fabric, close to where it came up, as shown (B). End by taking several stitches through the threads on the wrong side of your work.

French Knot

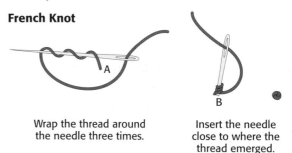

Wrap the thread around the needle three times.

Insert the needle close to where the thread emerged.

You can use the satin stitch to make the bird's beak and eye. Thread an embroidery needle with two strands of embroidery floss. Make straight stitches to cover the beak and eye areas. Keep the thread flat and smooth. There should be no spaces between the stitches.

Satin Stitch

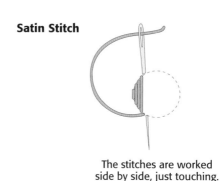

The stitches are worked side by side, just touching.

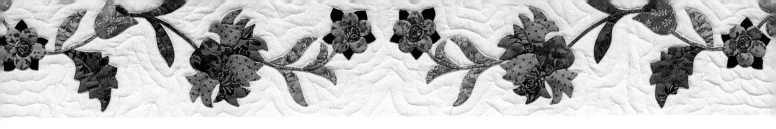

 ROTARY CUTTING

ONE OF THE greatest inventions in quilt-making history is the rotary cutter, a simple tool that has greatly increased both the speed and accuracy of our cutting. Follow these steps to rotary cut the pieced blocks and borders in this book.

A STRAIGHT START

FOLD THE FABRIC in half, selvage to selvage. Fold it in half once more by bringing the fold up to the selvage. Align the double-folded edge of the fabric with one of the marked lines on a rotary cutting mat. Position a long acrylic ruler at the left side of the fabric, with a smaller square acrylic ruler next to its right edge. This will help you establish a straight cutting edge at the left side of the fabric that is exactly perpendicular to the fold of the fabric. Remove the smaller square ruler, and rotary cut evenly along the right edge of the long ruler. After you have established this straight edge, it will be easy to cut strips, borders, and bindings accurately with the rotary cutter. Just remember the carpenter's rule—"measure twice, cut once."

Selvages

SQUARES AND RECTANGLES

To CUT SQUARES and rectangles, first cut a strip in the width required for your project. Then cut from it the number of squares or rectangles you need.

QUARTER-SQUARE TRIANGLES

To CUT QUARTER-SQUARE triangles, cut the size square indicated in your project, and then cut along the diagonals in both directions. This will give you four triangles that each have the straight grain along their long edges.

BIAS STRIPS

To CUT BIAS strips, align the 45° line on an acrylic ruler with the cut edge of your fabric. Cut along the ruler's long edge to create a bias cut in the fabric. Cut bias strips along this edge in the width needed for the stems in your project.

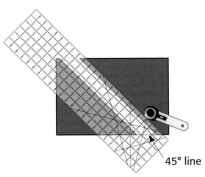

45° line

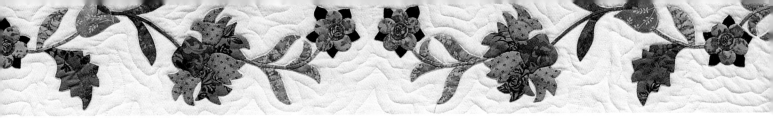

ACCURATE MACHINE PIECING

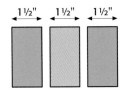

A SCANT ¼" SEAM allowance is crucial for accuracy in machine piecing. To test your own stitching accuracy, cut three strips of fabric, each 1½" wide x 3" long. Sew these three strips together along their lengths. Measure the finished width of the middle strip. If your sewing was accurate, it should measure exactly 1" wide. Using a scant ¼" seam allowance compensates for the thickness of the fabric in the seam allowances after the seam is pressed. Even if you have a ¼" presser foot for your sewing machine, you should still do this test and use it as your reference point for accuracy in all of your machine piecing.

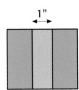

Chain piecing is a technique in which you keep feeding individual pieces or units into your sewing machine, in sequence, without cutting the thread between them. Use chain piecing whenever you can; it increases speed and accuracy, and saves thread.

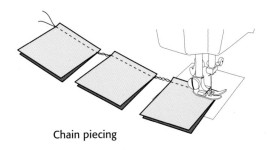

Chain piecing

When joining units, try to press so that seam allowances oppose each other whenever possible. That way, the seams nest together easily, and you will find that pinning is often unnecessary.

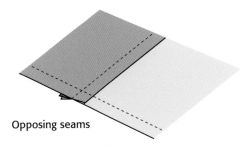

Opposing seams

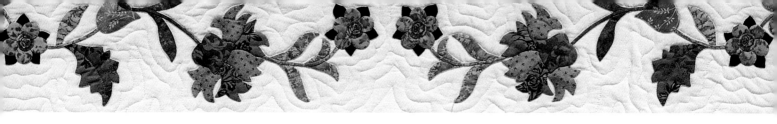

 PRESSING MATTERS

*O*FTEN, THE DIFFERENCE between a great quilt block and a not-so-great quilt block lies in the way it was pressed. Press seam allowances toward the darker fabric, whenever possible, to prevent the fabric in the darker seam allowance from showing through the lighter fabric in your quilt top as a shadow. It is acceptable to press seams open, if that will help a block to lie flatter.

For both appliqué and piecing, I steam press, but I am very careful not to stretch the block while I am pressing it. I do touch-up pressing on the wrong side of the block first, to make sure that all of the seam allowances lie in the direction I want them to. Then, I lightly mist the right side of the block with water and do the final pressing from the right side. Pressing is more of a lift-and-lower motion than a sideways movement. The main thing to avoid is moving the iron sideways while pressing down hard.

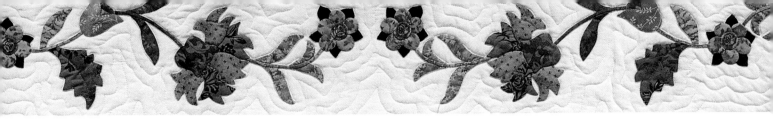

 # BORDERS WITH MITERED CORNERS

BEAUTIFUL BORDERS WITH corners that are straight and true make the perfect frame for any quilt top. Follow these steps to add borders with mitered corners to a quilt.

1. Measure your quilt top lengthwise through the center to determine the most accurate length for your quilt top. Find the center of a lengthwise border strip by folding it in half and marking it with a pencil. Pin the center of the lengthwise border strip to the center of the side of the quilt top so that the measurements on each side are equal to one half of the lengthwise measurement of your quilt top. Pin the remainder of the border strip to the quilt top. Sew the border strip onto the quilt top, stopping ¼" in from each corner. Backstitch to secure the seam. Repeat this step for the remaining 3 border strips.

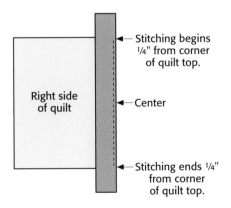

2. Fold the border strips at each corner so that they meet at a 45° angle. Press the border strips so that a crease line is formed at each corner.

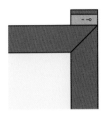

3. Pin the border strips together at the corners, matching up the crease lines. Start at the outside corner and sew *inward* to meet the stitching at the inside corner of the quilt top. Backstitch to end this seam. Trim the mitered corner seam allowances to ¼" and press them open.

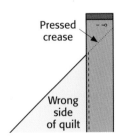

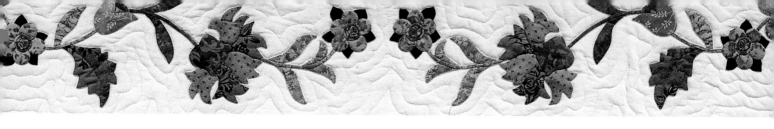

 QUILT FINISHING

SELECTING THE BATTING

I PREFER TO use cotton, a cotton/polyester blend, or a low-loft polyester batting in my quilts, because I like the look of a thinner quilt with lots of quilting on it. The low-loft polyester is easy to quilt through, especially for anyone who has a touch of arthritis, as I do. Thin battings look nice on a bed, and they also hang flat and smoothly on a wall.

 TIP: *It is best to open the batting the day before you plan to use it, so that it can relax and breathe. If you forget to do this, the alternative is to lightly mist the batting with water and then put it into a clothes dryer set on warm for a few minutes. This will help unwrinkle the batting.*

PREPARING THE BACKING

THE BACKING SHOULD be at least 2" larger all around than the quilt top. For quilt tops that are larger than approximately 38" to 39" square, you can either piece a backing from lengths of 42"-wide fabric, or use a backing fabric that comes in a wider width, such as 60", 90", or 108", so that the backing will not need to have any seams. If you decide to piece a backing for your quilt, it is a good idea to make sure that the joining seams do not lie at the center of the backing. I like to split a single width of fabric and sew one half of it onto each side of a full width of fabric to avoid a center seam. Quilts are often folded in half for storage, and a center backing seam can result in a very distinct crease line in this area of a quilt.

1 fabric width

Partial fabric width

Basting the Layers

Tape the backing right side down on a flat surface, like a floor or large table, so that it lies flat and stays taut. Lay the batting on top of the backing, smoothing it out so there are no wrinkles or creases. Lay the well-pressed quilt top, right side up, on top of the batting. Thread-baste the three layers of the quilt together, both horizontally and vertically, spacing the lines of basting stitches 4" to 6" apart, starting in the center of the quilt top and working outward toward the sides.

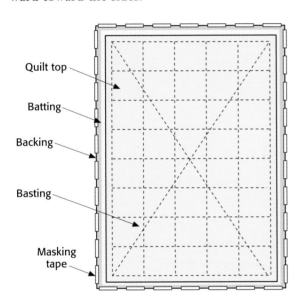

Hand Quilting

Quilting makes the quilt! Not only does quilting hold the layers of a quilt together, it creates wonderful visual dimension. Small, evenly spaced quilting stitches are an additional design element, so put as much quilting on your quilt as time allows. For more information on perfecting your hand quilting, refer to the book *Loving Stitches* by Jeana Kimball.

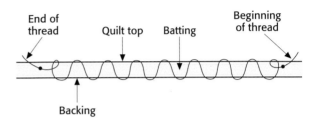

Attaching the Binding

The binding strips for the projects in this book are cut 2¼" wide on the straight grain of the fabric. Join the binding strips end-to-end until the binding is long enough to go around the perimeter of the quilt plus 10" more, to allow for mitering the corners. Then follow these steps to attach the binding to your quilt.

1. Fold the binding in half, wrong sides together, and press it to make a double-fold binding that is 1⅛" wide. It is easier to sew the binding onto the quilt before trimming the quilt batting and backing; you can hold onto the fabric more easily, and puckers will be less likely to form on the back side of the quilt.

2. Start sewing the binding onto the quilt somewhere along one side, leaving a 2" tail of binding free when you start. Use a walking foot and sew a ¼" seam through all the layers of the quilt. Keep the raw edges of the binding even with the raw edge of the quilt top. Stop sewing exactly ¼" from the next corner of the quilt, backstitch, and cut the thread. Fold the binding up so that the raw

edges are in line with the raw edges of the next side of the quilt.

Quilt top

3. Fold the binding back down on itself, even with the edge of the quilt top; this forms a little pleat at the corner, which later forms the miter at the corner. Begin stitching ¼" in from the edge, backstitching to secure. Repeat this process at each corner of the quilt, and continue stitching until you are about 3" from where you started.

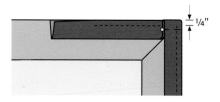

¼"

4. Stop stitching, and remove the quilt from your sewing machine. Fold the binding strips together where they should meet, and mark with a pencil.

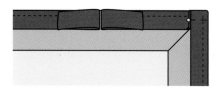

Mark where strips meet.

5. Sew a joining seam on the line you marked. Trim the seam to ¼" and finger press it open. Put the quilt back in your machine, and sew the remainder of the binding seam.

6. Trim the excess batting and backing even with the edge of the quilt top.

7. Fold the binding over the raw edges of the quilt. Hand sew the fold of the binding onto the back of the quilt so that the fold just covers the previous row of machine stitching. Fold the miter at each corner of the binding by hand, and slipstitch in place.

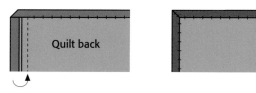

Quilt back

ADDING A LABEL

HERE IS A sample of the label that I used for my quilt. Use the letters and numbers provided on page 23 to make a special label for your own quilt by tracing onto a piece of fabric that has been stiffened slightly with fabric sizing. Use a fine-tip permanent marker, such as a Pigma .03 mm pen. Heat set the label after you are finished by pressing over it with a hot, dry iron on the cotton setting.

This Flowering Urn Quilt was made by Rosemary Makhan Burlington, Ontario 1998

A B C D E F G H I J K
L M N O P Q R S T U V
W X Y Z

a b c d e f g h i j k l m n o p q r s t u v w x y z

1 2 3 4 5 6 7 8 9 0

ATTACHING A HANGING SLEEVE

IF YOU PLAN to hang your quilt, sew a hanging sleeve, or casing, onto the top edge of the backing. It looks best to make the hanging sleeve from the same fabric as the backing, if possible, so that the sleeve will barely be noticeable on the wrong side of the finished quilt. Cut a strip for the sleeve that measures 8½" wide x the width of the top of the quilt, and sew a ¼" seam along the long edges to form a tube. Press this seam open. Hem the raw edges at the short ends by turning under ¼" and then 1", pressing, and then stitching the ends of the tube. Press the finished sleeve, making sure that the long seam is positioned at the middle of one side so that you can place this side of the sleeve against the quilt backing. Slipstitch the sleeve in place along the top edge of the quilt back, after the quilt is bound. Be careful to stitch through only the backing fabric and batting, rather than all the way through to the front side of the quilt.

FLOWERING URN WALL HANGING

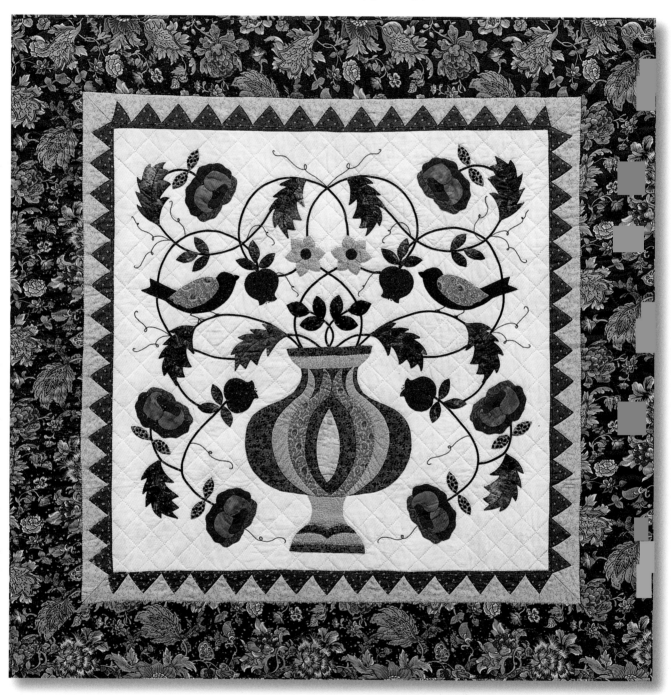

Made by Janet Henry, 2000, Oakville, Ontario, Canada. The beautiful chintz border fabric and Janet's wonderful fabric choices for the center block make this wall hanging very special.

FABRICS

(42" wide after prewashing, unless otherwise indicated)

- 1 yd. cream background fabric for Flowering Urn center block
- ⅜ yd. each of green print and tan print for dogtooth border
- 1½ yds. chintz or other large-scale print for outer border and binding
- 1½ yds. 60"-wide fabric for backing and casing
- 1 fat quarter each of 3 light to medium shades of red for roses
- 1 fat eighth each of 2 dark shades of red for roses
- 1 fat eighth plum for pomegranates
- 1 fat eighth each of 2 shades of blue for birds
- 1 small scrap black for beaks
- 1 fat eighth gold for small flower petals
- 1 small scrap plum for small flower centers
- 1 fat quarter each of 4 shades of gold for urn
- ½ yd. main green for large leaves and stems
- 1 fat eighth each of 3 different shades of green for small leaves

CUTTING

From the cream background fabric, cut:
- 30½" x 30½" square for Flowering Urn center block (Finished block size: 30" x 30")

From the appliqué fabrics, prepare:
- the pieces shown on pages 28–33

From the green print, cut:
- 4 strips, each 2½" x 36", for dogtooth border

From the tan print, cut:
- 4 strips, each 2½" x 36", for dogtooth border

From the chintz or other large-scale print, cut:
- 4 strips, each 5½" x 46", for outer border
- 4 strips, each 2¼" x 48", for binding

From the backing fabric, cut:
- 1 square, 48" x 48", for backing
- 1 strip, 8½" x 44", for casing

FLOWERING URN CENTER BLOCK

1. Prepare and stitch the Flowering Urn center block, referring to the placement diagram on page 27, the patterns on pages 28–33, the instructions for "Freezer Paper Appliqué" on page 10, and "Preparing Narrow Bias Stems" on page 12.

2. Embroider the tendrils, pomegranate seeds, and birds' eyes and legs, referring to the instructions for "Embroidery Stitches" on page 15.

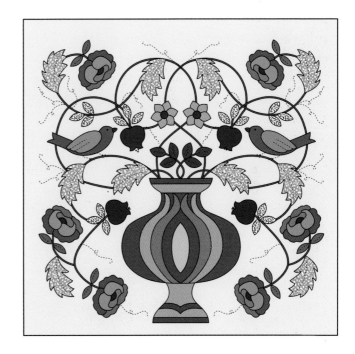

ADDING THE BORDERS
Dogtooth Border

1. Fold the 2½" x 36" green print strips in half crosswise to find the center points, and mark them lightly with a pencil on the wrong side of the fabric.

2. Press under ¼" along 1 long edge of each green strip. Then draw a line ¾" in from the opposite long edge of each green strip.

3. The center point on each side of the Flowering Urn center block will line up with the center point of the dogtooth triangle at the middle of each green strip. To align, measure 1" from the center point of each green strip in both directions. At these points, mark vertical lines that go from the folded edge to the drawn ¾" line. Then mark the remaining dogtooth triangles, measuring and marking lines 2" apart in both directions along the entire green strip, referring to the diagram below.

4. Cut along these marks, except for the last mark nearest each end of the green strip, so that you can adjust the corner dogtooth triangle later, if necessary. Fold, press, and glue each cut section so that the dogtooth triangles are formed along the green strips. The points of the dogtooth triangles should be even with the fold of the fabric.

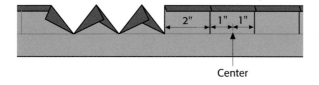

Center

5. Place the prepared green strips on the tan print strips, lining up both straight edges accurately on top of each other. The points at the tops of the dogtooth triangles should lie ¼" in from the cut edge of the tan print strip. On Janet's quilt there is slightly more space showing.

6. Appliqué the green print dogtooth strip onto the tan print strip, being especially careful to secure the tips of the triangles; take small, closely spaced stitches at the bases of the triangles.

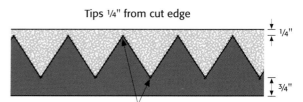

Tips ¼" from cut edge

Take several tiny stitches at the inner points and at bases of triangles.

7. Sew the dogtooth border strips onto the Flowering Urn center block, stopping ¼" away from each corner and backstitching to secure each seam. Adjust and sew the end triangles as necessary to stitch the mitered corner seams. For more information on mitering corner seams, see page 19. Sew each corner triangle seam with a small slip stitch by hand. Press the block seams toward the dogtooth border.

Outer Border

1. Sew the 5½" x 46"-wide outer border strips to the quilt, referring to "Borders with Mitered Corners" on page 19.

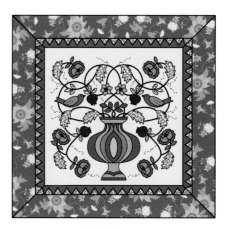

Quilt Diagram

QUILTING AND FINISHING

1. Press the completed quilt top and trim any long threads.

2. Using a yardstick, mark diagonal crosshatch lines on the Flowering Urn center block, using the 2" measurement at the base of each "dog tooth" as the interval between these lines.

3. Mark straight lines across the width of the outer border, using the increments of the dogtooth as your guide. Another option is to mark the outer border with a simple, curved quilting pattern of your choice.

4. Layer and baste the backing, batting, and quilt top, referring to the instructions for "Basting the Layers" on page 21.

5. Outline-quilt ⅛" outside all the appliqué shapes and along the edges of the dogtooth triangles. Quilt the marked grid lines in the Flowering Urn center block and the outer border.

6. Bind the quilt, referring to "Attaching the Binding" on page 21.

7. Make a label and hanging sleeve, referring to "Adding a Label" on page 22 and to "Attaching a Hanging Sleeve" on page 23.

PLACEMENT DIAGRAM FOR CENTER BLOCK

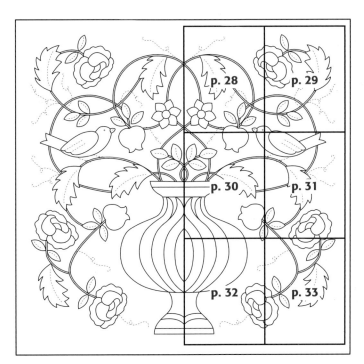

Flowering Urn Center Block

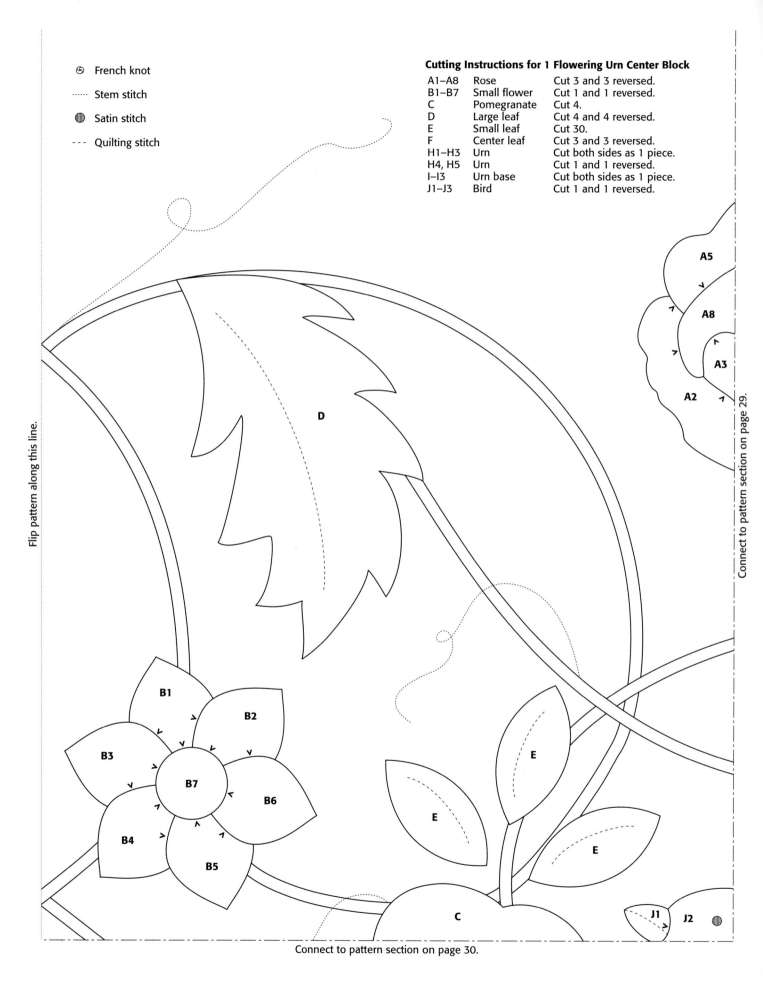

⑤ French knot

······ Stem stitch

▥ Satin stitch

- - - Quilting stitch

Cutting Instructions for 1 Flowering Urn Center Block

A1–A8	Rose	Cut 3 and 3 reversed.
B1–B7	Small flower	Cut 1 and 1 reversed.
C	Pomegranate	Cut 4.
D	Large leaf	Cut 4 and 4 reversed.
E	Small leaf	Cut 30.
F	Center leaf	Cut 3 and 3 reversed.
H1–H3	Urn	Cut both sides as 1 piece.
H4, H5	Urn	Cut 1 and 1 reversed.
I–I3	Urn base	Cut both sides as 1 piece.
J1–J3	Bird	Cut 1 and 1 reversed.

Flip pattern along this line.

Connect to pattern section on page 29.

Connect to pattern section on page 30.

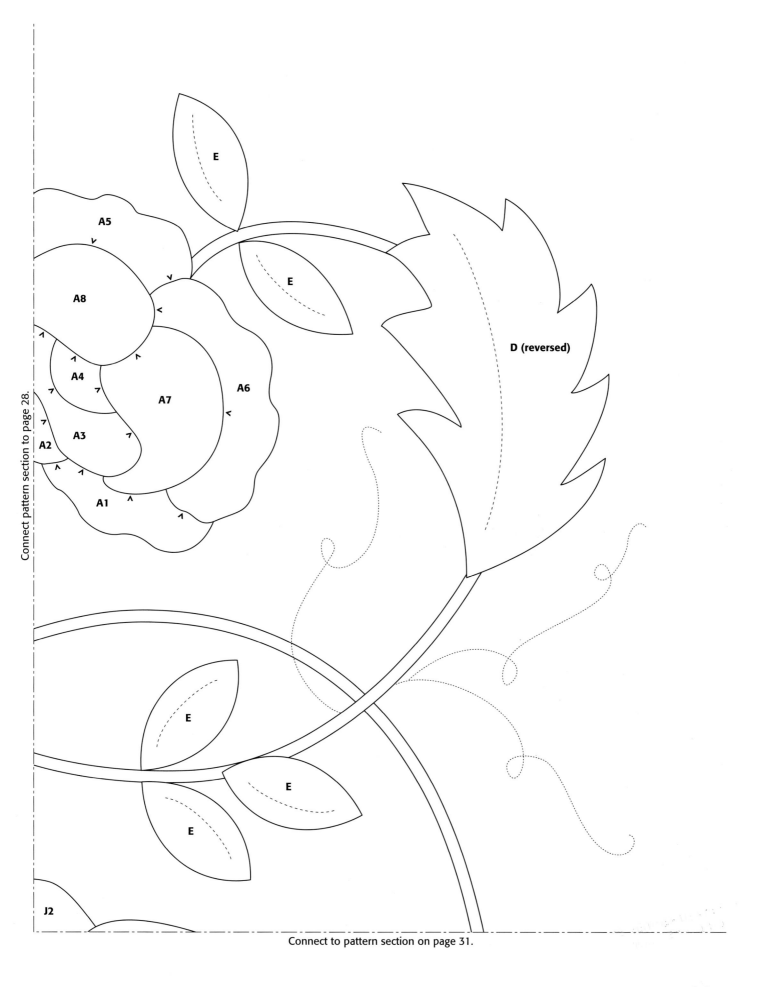

Connect pattern section to page 28.

E

A5

A8

A4

A3

A2

A7

A6

A1

E

D (reversed)

E

E

E

J2

Connect to pattern section on page 31.

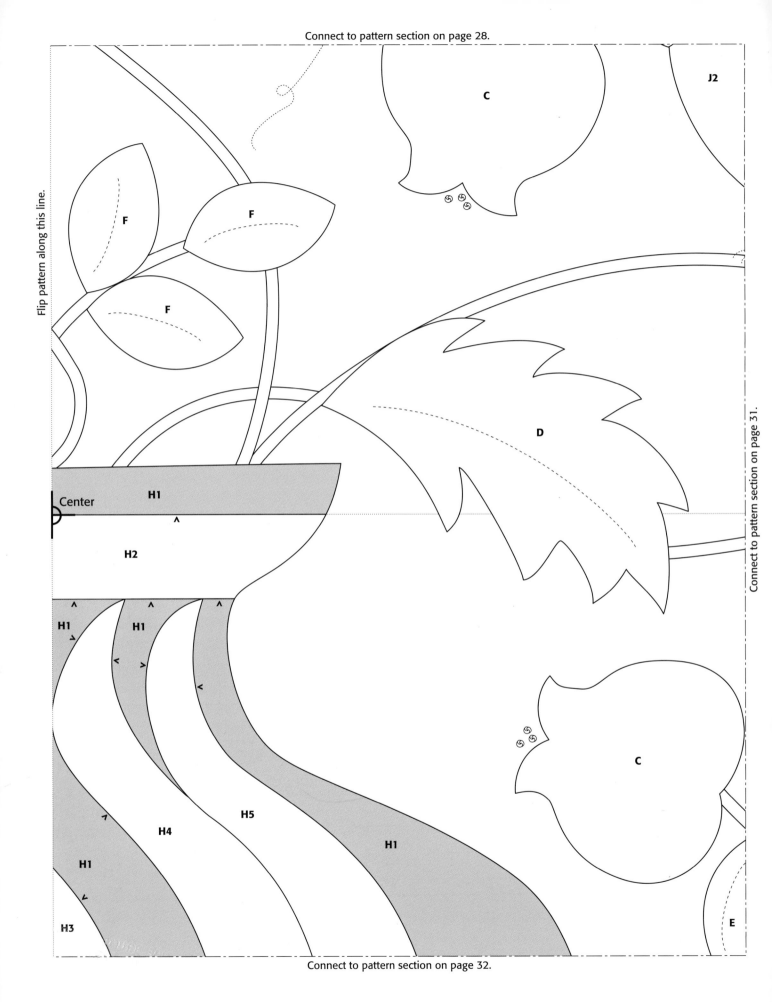

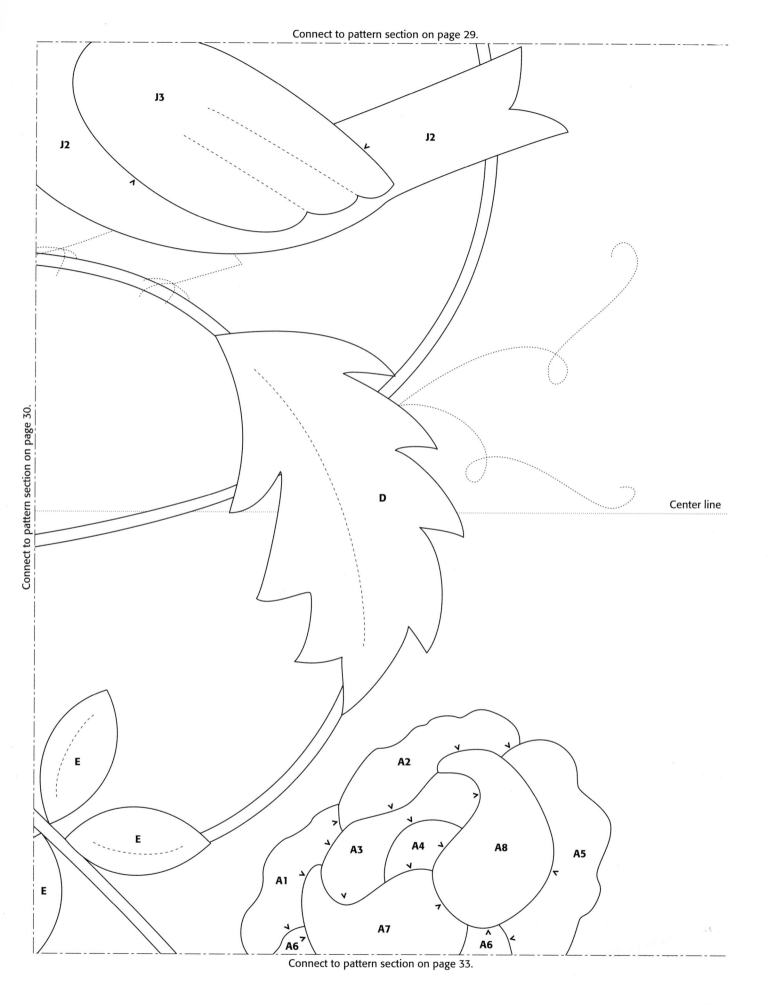

Connect to pattern section on page 30.

Center line

H3

< H1 >

H4 >

H5

< H1

Flip pattern along this line.

Connect to pattern section on page 33.

I1

I3

I1

I2

A5

A8

A2

A3

A4

A7

A1

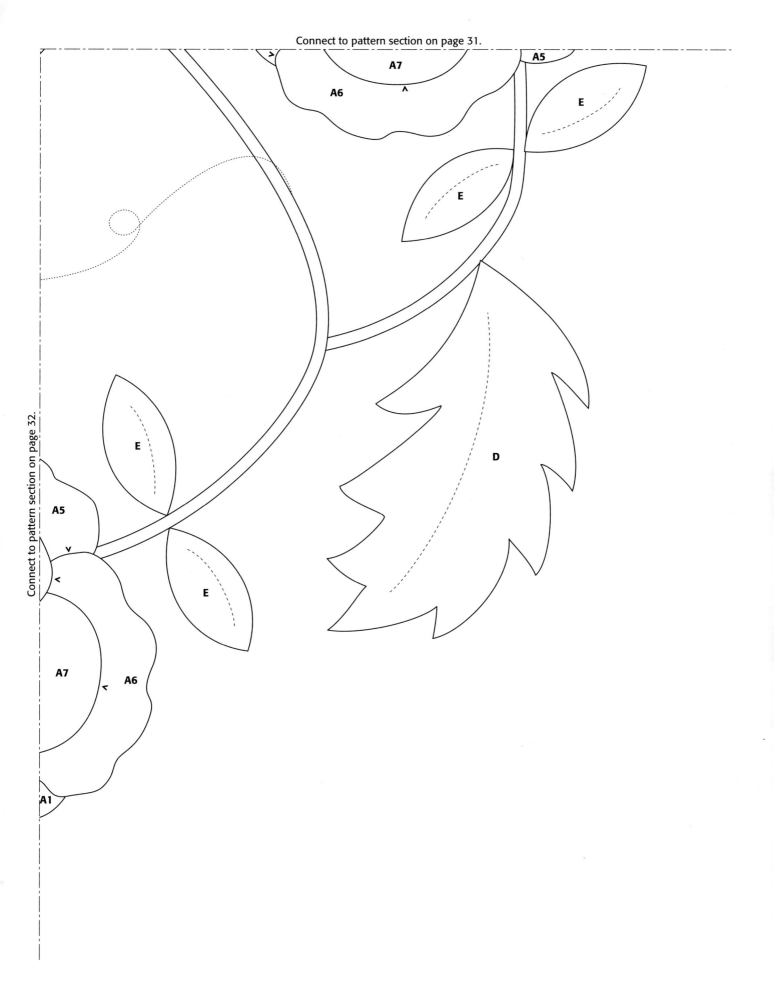

Connect to pattern section on page 32.

FLOWERING URN MEDALLION QUILT

FINISHED SIZE: 84" x 84"

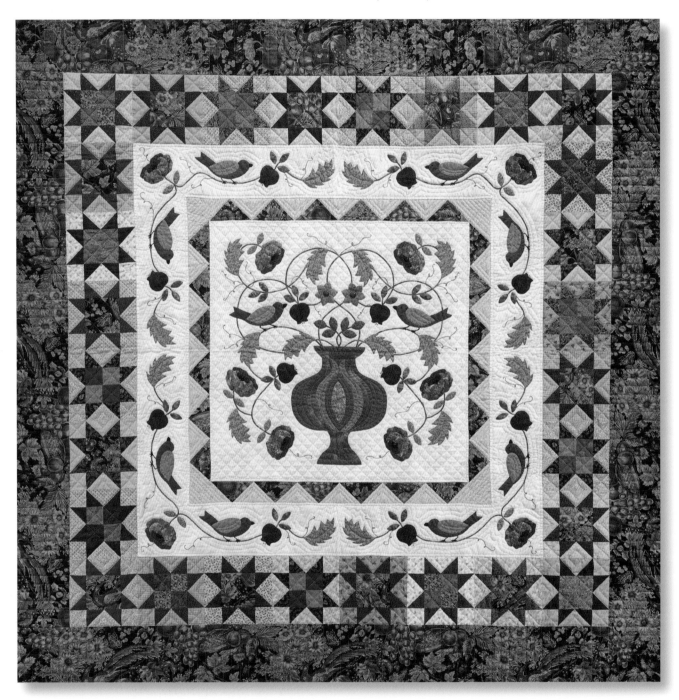

Made by Rosemary Makhan, 1999, Burlington, Ontario, Canada. The border fabric I used in this quilt reminded me of William Morris's textiles and provided the initial inspiration that led me to design all of the quilts shown in this book.

FABRICS

(42" wide after prewashing, unless otherwise indicated)

- 2½ yds. mottled, tea-dyed, or tone-on-tone background fabric for Flowering Urn center block and appliqué border
- 1 fat quarter each of 3 light to medium shades of red for roses
- 1 fat eighth each of 2 dark shades of red for roses
- 1 fat quarter purple for pomegranates
- 1 fat quarter each of 2 shades of blue for birds
- 1 small scrap black for beak
- 1 fat eighth gold for petals of small flowers
- 1 small scrap tan print for flower centers
- 1 fat quarter each of 4 shades of gold for urn
- 1 fat quarter each of 3 shades of green for small leaves
- ½ yd. main green for large leaves and stems
- ½ yd. tan print for triangle border
- 3⅝ yds. chintz or other large-scale print for triangle border, Star block border, outer border, and binding
- Assorted fat eighths or scraps of light and medium background prints for Star block border
- Assorted fat eighths of medium and dark prints for Star block border
- 3 yds. 90"-wide fabric for backing and casing

CUTTING

From the mottled, tea-dyed, or tone-on-tone print, cut:

- 1 square, 30½" x 30½", for Flowering Urn center block (Finished block size: 30" x 30")
- 4 strips, each 6½" x 50", for appliqué border (These border strips are 2" longer than necessary and will be trimmed later.)

From the appliqué fabrics, prepare:

- the pieces shown on pages 28–33 and 39–43

From the tan print, cut:

- 7 squares, each 6¼" x 6¼", for triangle border; cut these squares twice diagonally to yield 28 triangles.

From the chintz or other large-scale print, cut:

- 6 squares, each 6¼" x 6¼"; cut the squares twice diagonally to yield 24 triangles for triangle border
- 14 squares, each 4½" x 4½", for Star block centers
- 4 strips *from the length of the fabric*, each 10½" x 86", for outer border
- 9 strips, each 2¼" x 42", for binding

From the assorted light and medium background prints, cut:

- 112 squares, each 2½" x 2½", for Star blocks (each block requires 4 from the same fabric)
- 112 rectangles, each 2½" x 4½", for Star blocks (each block requires 4 from the same fabric)

From the assorted medium prints, cut:

- 28 squares, each 2½" x 2½", for Star block pieced centers (each block requires 2 from the same fabric)

From the assorted dark prints, cut:

- 28 squares, each 2½" x 2½", for Star block pieced centers (each block requires 2 from the same fabric)

From the assorted medium and dark fabrics, cut:

- 224 squares, each 2½" x 2½", for Star block points (each block requires 8 from the same fabric)

From the backing fabric, cut:

- 1 square, 88" x 88", for backing
- 1 strip, 8½" x 84", for casing

FLOWERING URN CENTER BLOCK

1. Prepare and stitch the Flowering Urn center block, referring to the placement diagram on page 38, the patterns on pages 28–33, the instructions for "Freezer Paper Appliqué" on page 10, and "Preparing Narrow Bias Stems" on page 12.

2. Embroider the tendrils, pomegranate seeds, and birds' eyes and legs, referring to the instructions for "Embroidery Stitches" on page 15.

ADDING THE BORDERS

Triangle Border

1. Sew a tan print triangle to a chintz or large-scale print triangle as shown. Make 24 of these units.

Make 24.

2. Sew 6 triangle units together to make each of the 4 triangle borders. You will need to add 1 extra tan print triangle at the end of each triangle border, as shown.

Sew 6 units together and add tan triangle to end.

Make 4.

3. Sew the triangle borders to the Flowering Urn center block, beginning and ending your line of stitching ¼" in from the edge at each corner, and backstitch to secure the seam. Press the seam allowances toward the triangle border.

4. Sew the diagonal seams at each corner of the triangle border, working from the outer edge toward the inner edge of the border. Backstitch when you meet the previous stitching at each corner. Press these seam allowances open.

Appliqué Border

1. Prepare and stitch the appliqué border strips, referring to the diagram on page 38, the patterns on pages 39–43, the instructions for "Freezer Paper Appliqué" on page 10, and "Preparing Narrow Bias Stems" on page 12. Wait to stitch the corner flowers, leaves, and stems until after you attach the appliqué borders to the quilt.

NOTE: *In the top appliqué border strip only, the birds' legs are positioned so they face toward the Flowering Urn center block, rather than away from it, as in the other three border strips. Because of this, the vines will meet slightly differently at the top corners of the appliqué border; refer to the quilt diagram on page 38.*

2. Sew the appliqué border strips onto the quilt. Miter the corner seams, referring to "Borders with Mitered Corners" on page 19. Press the seam allowances toward the triangle border.

3. Appliqué the flower, stems, and leaves at each corner of the appliqué border.

Star Block Border

1. Sew 1 medium and 1 dark 2½" x 2½" square together. Repeat. Sew these 2 units together to form a pieced Star block center. Make a total of 14 of these pieced Star block centers.

NOTE: *The remaining Star block centers will be unpieced 4½" x 4½" squares from the chintz or large-scale print.*

Make 14.

2. Mark a diagonal line from corner to corner on the wrong side of each of the medium or dark 2½" x 2½" squares for the Star block points.

Mark diagonal.

3. Place a medium or dark 2½" x 2½" square at each end of a background print rectangle, with right sides together. Do not stitch *on* the marked line; instead, sew just *beside* it, on the side of the line that lies toward the corner of the rectangle. Trim the fabric on this side of the seam, leaving a ¼" seam allowance, and press the seam allowance toward the triangle. Make a total of 4 of these units for each of the 28 Star blocks.

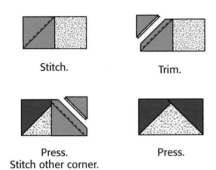

Stitch. Trim.

Press. Press.
Stitch other corner.

4. Sew each Star block together in 3 vertical rows, as shown, making 14 blocks with pieced 4-patch centers and 14 blocks with unpieced square centers. Join the vertical rows together to complete the Star blocks. Make a total of 28 Star blocks.

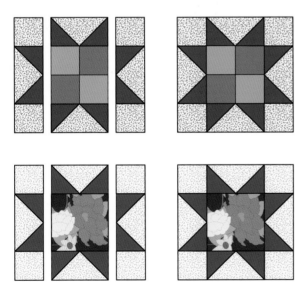

5. Referring to the quilt diagram on page 38, sew together 2 rows of 6 Star blocks each for the side Star block border strips, alternating the pieced and unpieced centers.

6. Sew the side Star block border strips to the quilt. Press the seam allowances toward the quilt center, unless they shadow through the background fabric. If this happens, press the seam allowances toward the side Star block border strips.

7. Sew together 2 rows of 8 Star blocks each for the top and bottom Star block border strips; alternate the 2 different types of centers, as before.

8. Sew the top and bottom Star block border strips to the quilt. Press the seam allowances as before.

Outer Border

1. Sew the 10½" x 86" outer border strips onto the quilt, referring to "Borders with Mitered Corners" on page 19.

2. Press the seam allowances toward the outer border.

QUILTING AND FINISHING

1. Press the completed quilt top and trim any long threads.

2. Mark diagonal crosshatching lines on the background of the Flowering Urn center block, using the sections of the triangle border as your guide. Draw 1 line from the edge of each triangle and 1 line from the center of each triangle. I also added another line between these lines, but this is not necessary unless you like lots of quilting on a quilt, as I do. Draw the diagonal lines in both directions to create a crosshatch effect.

3. Layer and baste the backing, batting, and quilt top, referring to the instructions for "Basting the Layers" on page 21.

4. Outline-quilt ⅛" outside all of the appliqué shapes on the Flowering Urn block. Quilt the diagonal grid lines in the background areas.

5. Outline-quilt ½" inside each chintz triangle in the triangle border. Outline-quilt ⅛" inside the tan triangles next to the chintz triangles. Echo-quilt lines spaced ½" apart inside the tan triangles.

6. Outline-quilt ⅛" outside the shapes in the appliqué border. Outline-quilt ¼" inside the long edges of the appliqué border. Echo-quilt lines spaced at ½" intervals around the appliqué shapes to fill in the remaining background areas.

7. Quilt diagonal lines on the Star blocks, using the grids of the Star blocks as your guidelines.

8. Quilt horizontal lines spaced at 1" intervals across the width of the outer borders. Use the divisions in the Star blocks as a guide for quilting these lines.

9. Bind the quilt, referring to "Attaching the Binding" on page 21.

10. Make a hanging sleeve and label, referring to "Attaching a Hanging Sleeve" on page 23 and to "Adding a Label" on page 22.

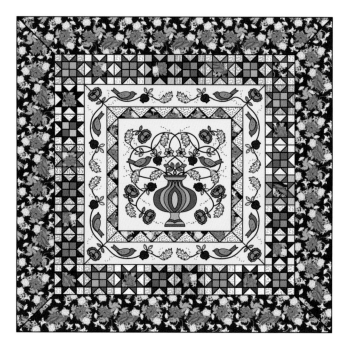

Quilt Diagram

PLACEMENT DIAGRAMS FOR CENTER BLOCK AND BORDER

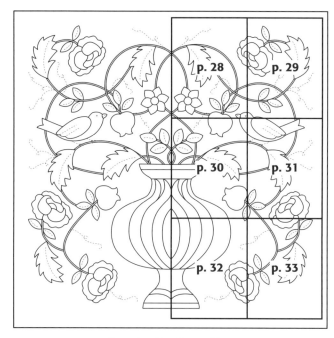

Flowering Urn Center Block

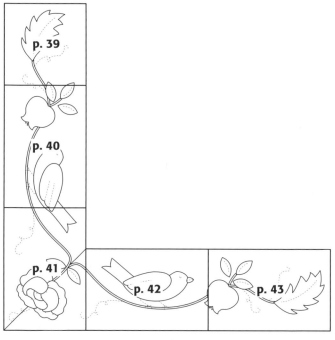

Border

Cutting Instructions for Border

A1–A8	Rose	Cut 2 and 2 reversed.
C	Pomegranate	Cut 8.
D	Large leaf	Cut 4 and 4 reversed.
E	Small leaf	Cut 32.
J1–J3	Bird	Cut 4 and 4 reversed.

Flip pattern along this line.

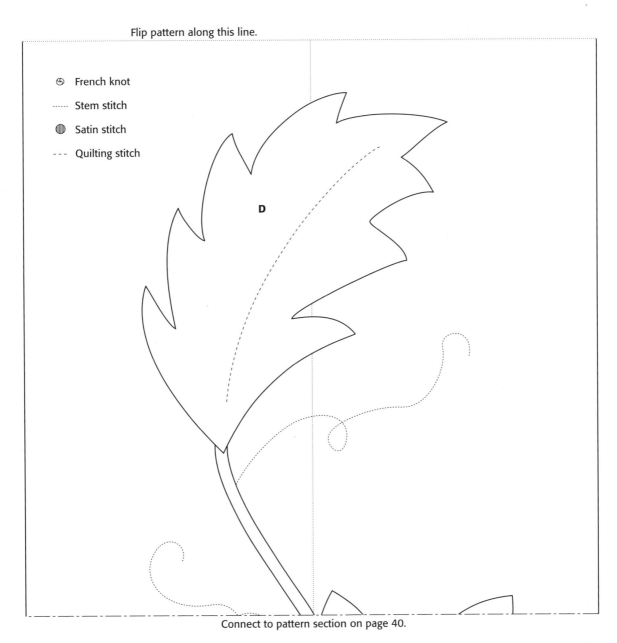

French knot

Stem stitch

Satin stitch

Quilting stitch

D

Connect to pattern section on page 40.

Connect to pattern section on page 39.

Remember that to place bird facing up on the top border, you need to reposition the stem.

Connect to pattern section on page 41.

Connect to pattern section on page 40.

Connect to pattern section on page 42.

Connect to pattern section on page 43.

J1 (reversed) →

J2 (reversed)

J3 (reversed)

Connect to pattern section on page 41.

Flip pattern along this line.

D (reversed)

E

E

E

C

Connect to pattern section on page 42.

FLOWERING URN FOUR-BLOCK QUILT

FINISHED SIZE: 88" x 88"

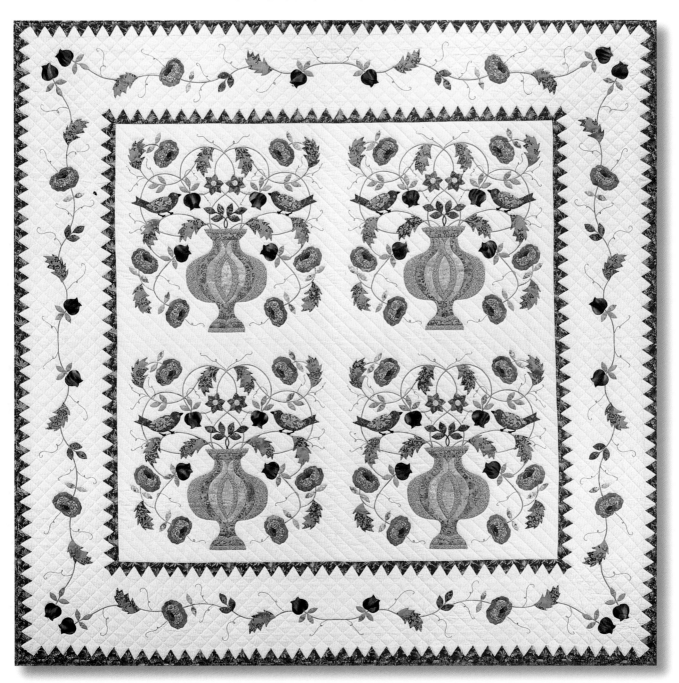

Made by Anne Gilmore, 2000, Hamilton, Ontario, Canada. Anne's superb workmanship is clearly evident in this exceptional quilt. Anne is a very dedicated quilter; she completed the appliqué and hand quilting on this quilt in just under seven months—while also working full time.

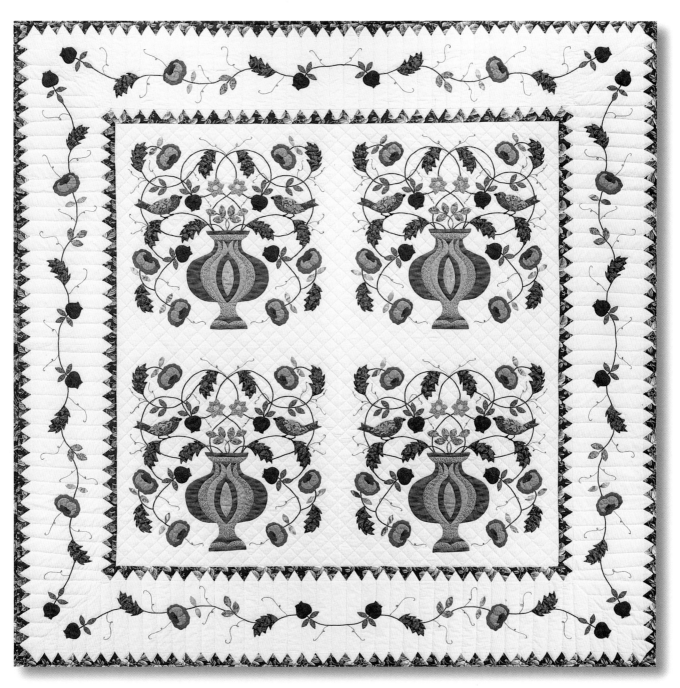

Appliquéd by Karen L'Ami, 2000, Oakville, Ontario, Canada. Karen took great delight in surprising me with the speed of her workmanship. She has been known to repeat the same class three or four times, so we have a standing joke about how many classes it will take to get a quilt done, each time she takes one of my classes. Quilted by Susan Rankin and "True Friends"—Cathy Cormier, Judy Garden, Anne Gilmore, Vicki Grafham, Teresa Kidd, Michelle Kranjc, Cathy Lamothe, Ruth Landon, Margaret Langlois, Grace Maloney, Jill Pettit, Joan Raynor, Carolyne Sparling, and Diane Thurner.

FABRICS

(42" wide after prewashing, unless otherwise indicated)

- 8 yds. tone-on-tone cream print background fabric for Flowering Urn blocks, dogtooth borders, and appliqué border
- 1 fat quarter each of 2 dark rose prints for roses
- ½ yd. each of 3 medium to light rose prints for roses—this makes a total of 5 different fabric values for the roses
- 1 fat quarter shaded brownish-purple for pomegranates
- 2 fat quarters blue for birds
- 1 small scrap black for beaks
- 1 fat eighth purple or gold for small flowers
- 1 small scrap gold for small flower centers
- 1 fat quarter each of 3 shades of gold for urn
- ½ yd. gold print for outside edges of urn
- 1 yd. each of 2 main green prints for leaves and stems
- 1 fat quarter each of 2 shades of green for small leaves
- 2¾ yds. medium to dark print for dogtooth borders and binding
- 3 yds. 108"-wide fabric for backing and casing

CUTTING

From the cream background fabric, cut:

NOTE: *First cut 4 background squares for Flowering Urn blocks; then cut background strips for the dogtooth borders from the length of the background fabric.*

- 4 squares, each 30½" x 30½", for Flowering Urn blocks (Finished block size: 30" x 30")
- 4 strips *from the length of the fabric*, each 2½" x 66", for inner dogtooth border
- 4 strips *from the length of the fabric*, each 10½" x 86", for appliqué border
- 4 strips *from the length of the fabric*, each 2½" x 90", for outer dogtooth border

From the appliqué fabrics, prepare:

- the appliqué pieces shown on pages 28–33 and 48–53

From the medium to dark print, cut:

- 4 strips *from the length of the fabric*, each 2½" x 66", for inner dogtooth border
- 4 strips *from the length of the fabric*, each 2½" x 90", for outer dogtooth border
- 4 strips *from the length of the fabric*, each 2¼" x 94", for binding

From the backing fabric, cut:

- 1 square, 92" x 92", for backing
- 1 strip, 8½" x 88", for casing

FLOWERING URN BLOCKS

1. Prepare and stitch 4 Flowering Urn blocks, referring to the placement diagram on page 47, the patterns on pages 28–33, the instructions for "Freezer Paper Appliqué" on page 10, and "Preparing Narrow Bias Stems" on page 12.

2. Embroider the tendrils, pomegranate seeds, birds' eyes, and birds' legs, referring to the instructions for "Embroidery Stitches" on page 15.

3. Sew the 4 Flowering Urn blocks together. Press the seam allowances open.

ADDING THE BORDERS
Inner Dogtooth Border

1. Stitch 4 inner dogtooth border strips, following the directions for the dogtooth border strips in the "Flowering Urn" wall hanging on page 24. For this project, the center of the quilt top should line up with the space between 2 of the dogtooth triangles.

2. Referring to page 26, sew the inner dogtooth border strips to the quilt top in the same manner as for the "Flowering Urn" wall hanging on page 24. Press the seam allowances toward the dogtooth border.

Appliqué Border

1. Prepare and stitch the appliqué border strips, referring to the quilt diagram at right, the placement diagram on page 48, and the pattern pieces on pages 48 to 53.

2. Sew the appliqué border strips to the quilt top, mitering the corner seams, referring to "Borders with Mitered Corners" on page 19. Press the corner seam allowances open. Press the border seam allowances toward the appliqué border strips.

Outer Dogtooth Border

1. Stitch the 4 outer dogtooth border strips in the same manner as for the inner dogtooth border.

2. Sew the outer dogtooth border strips to the quilt top in the same manner as for the inner dogtooth border. Press the seam allowances toward the appliqué border.

Quilting and Finishing

1. Press the completed quilt top and trim any long threads.

2. Using a yardstick, mark diagonal lines in one or both directions on the 4 Flowering Urn blocks, using the 2" measurement of the dogtooth triangles as your guide.

3. Mark straight lines across the width of the appliqué border, using the dogtooth triangles as your guide. Another option is to mark diagonal crosshatch lines on the appliqué border, using the dogtooth triangles as your guide.

4. Layer and baste the backing, batting, and quilt top, referring to the instructions for "Basting the Layers" on page 21.

5. Outline-quilt ⅛" outside all the appliqué shapes and along the edge of the dogtooth triangles.

6. Quilt along the marked lines in the Flowering Urn blocks and the appliqué border.

7. Bind the quilt, referring to "Attaching the Binding" on page 21.

8. Make a hanging sleeve and label, referring to "Attaching a Hanging Sleeve" on page 23 and to "Adding a Label" on page 22.

Quilt Diagram

Placement Diagram for Flowering Urn Block

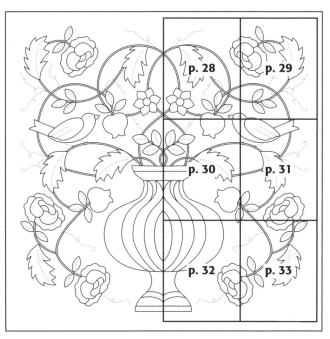

p. 28 p. 29 p. 30 p. 31 p. 32 p. 33

See page 48 for border placement diagram.

⑤ French knot

······ Stem stitch

◉ Satin stitch

--- Quilting stitch

Cutting Instructions for Border

A1–A8	Rose	Cut 4 and 4 reversed.
C	Pomegranate	Cut 16.
D	Large leaf	Cut 8 and 8 reversed.
E	Small leaf	Cut 64.
F	Center leaf	Cut 12 and 12 reversed.

E

E

E

C

Connect to pattern section on page 49.

Flip pattern along this line.

Placement Diagram for Border

p. 48	p. 49	p. 50	p. 51	p. 52	p. 53

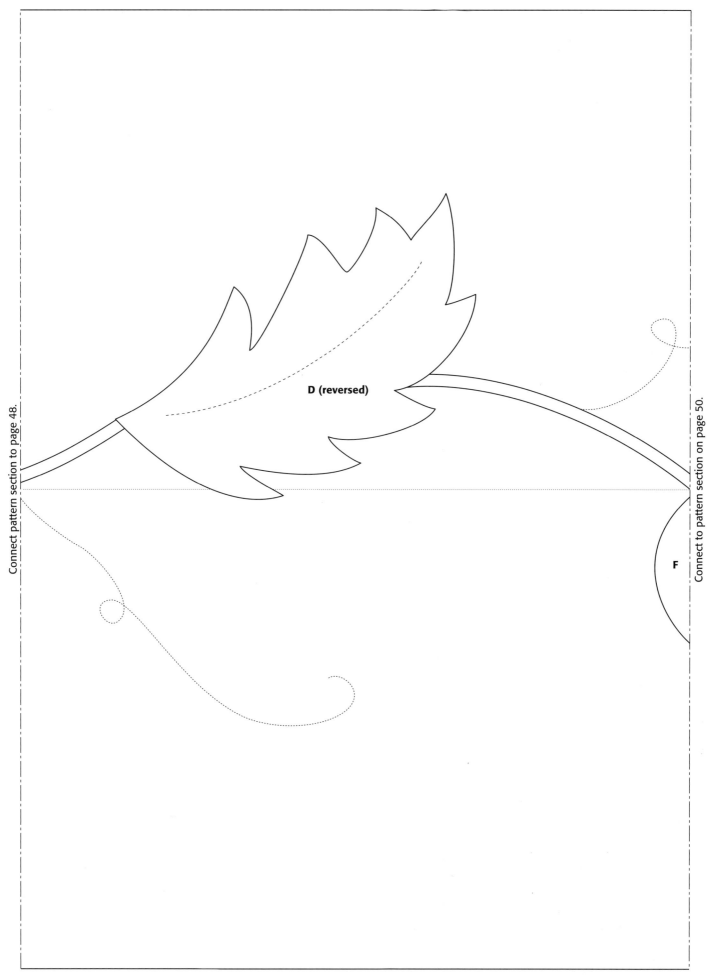

Connect pattern section to page 48.

D (reversed)

Connect to pattern section on page 50.

F

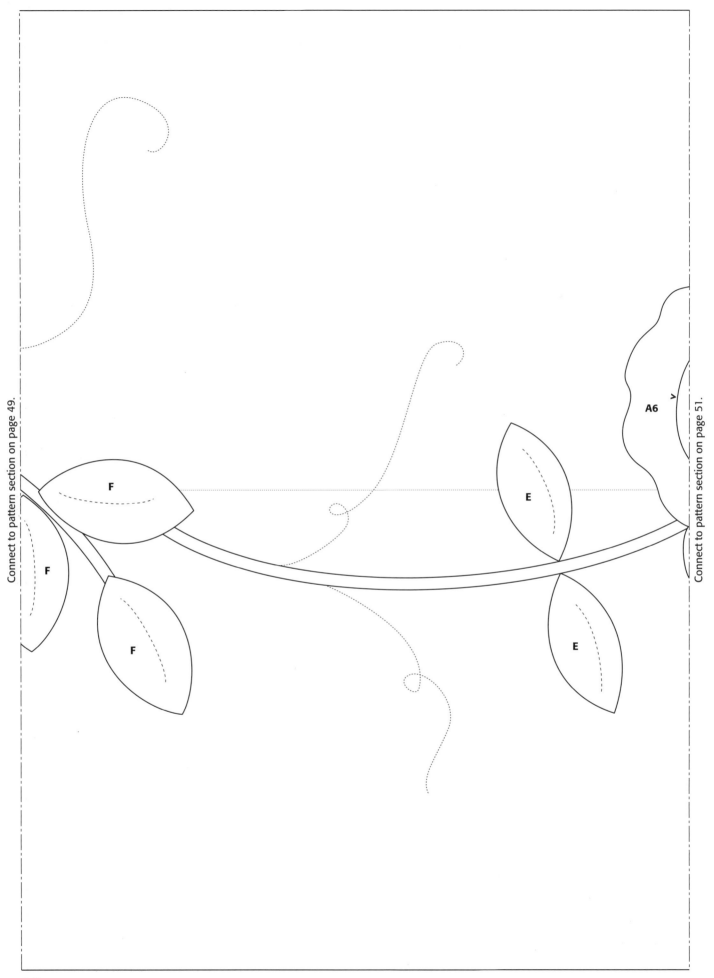

Connect to pattern section on page 49.

Connect to pattern section on page 51.

F

F

F

E

E

A6

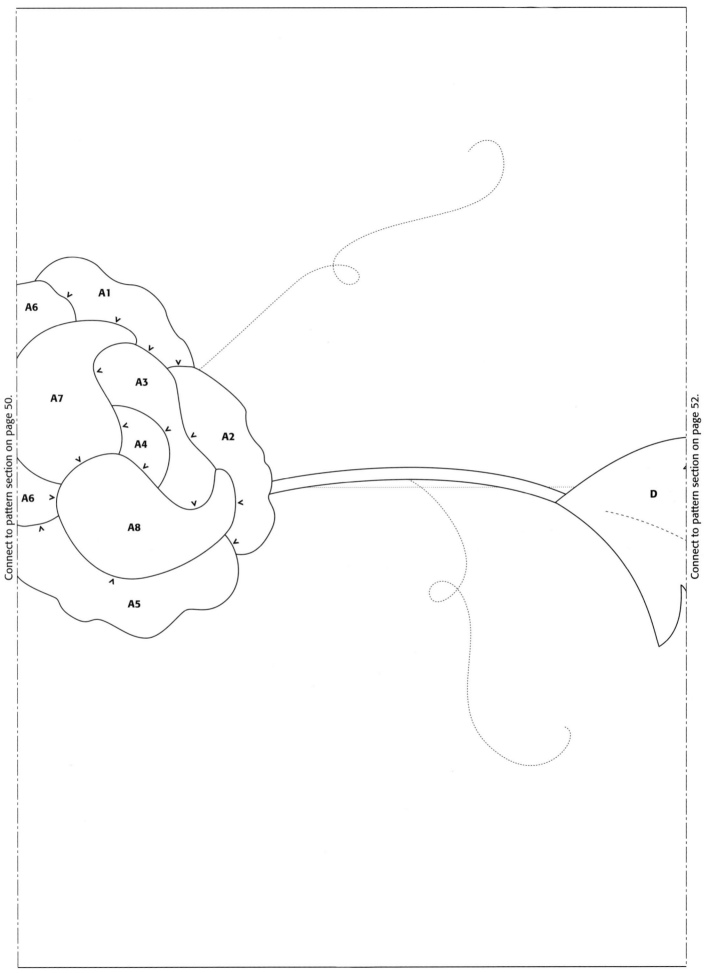

Connect to pattern section on page 50.

Connect to pattern section on page 52.

A6

A1

A7

A3

A4

A2

A6

A8

A5

D

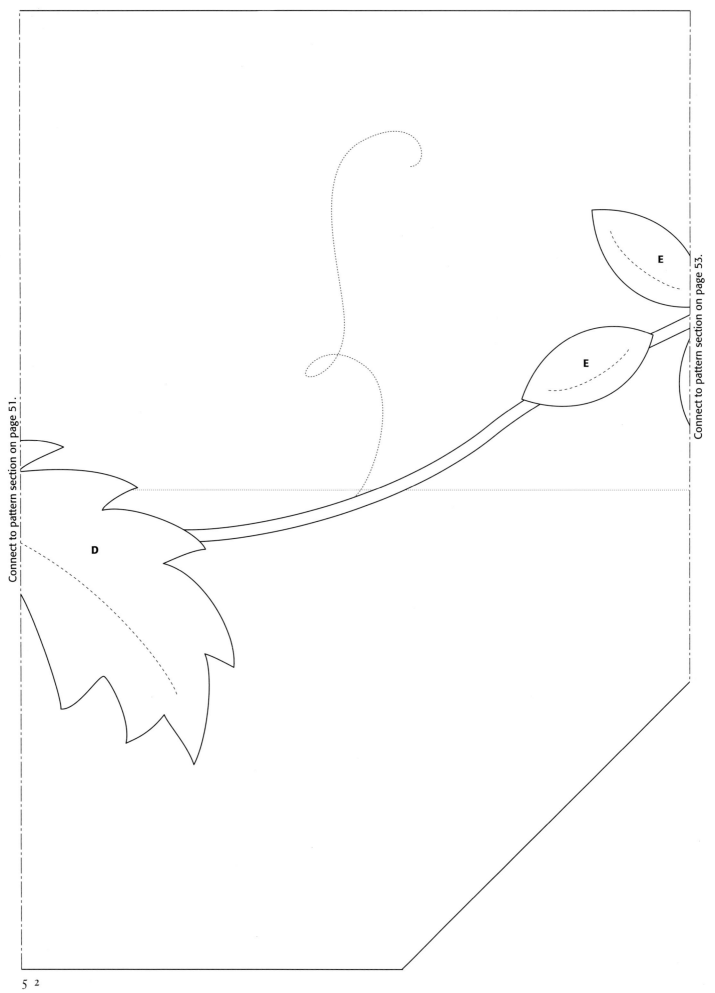

Connect to pattern section on page 51.

Connect to pattern section on page 53.

D

E

E

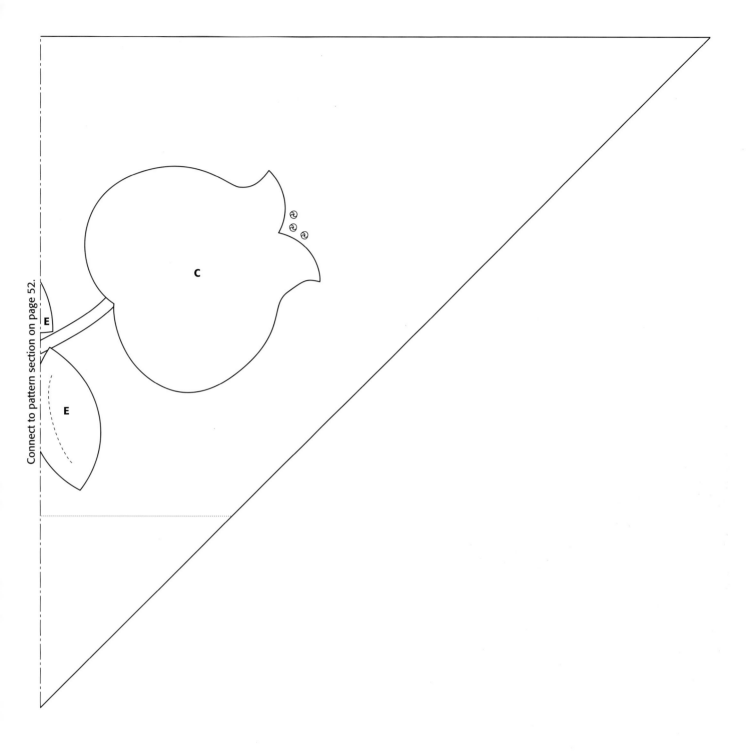

Connect to pattern section on page 52.

C

E

E

STRAWBERRY SEASON WALL HANGING

FINISHED SIZE: 42" X 42"

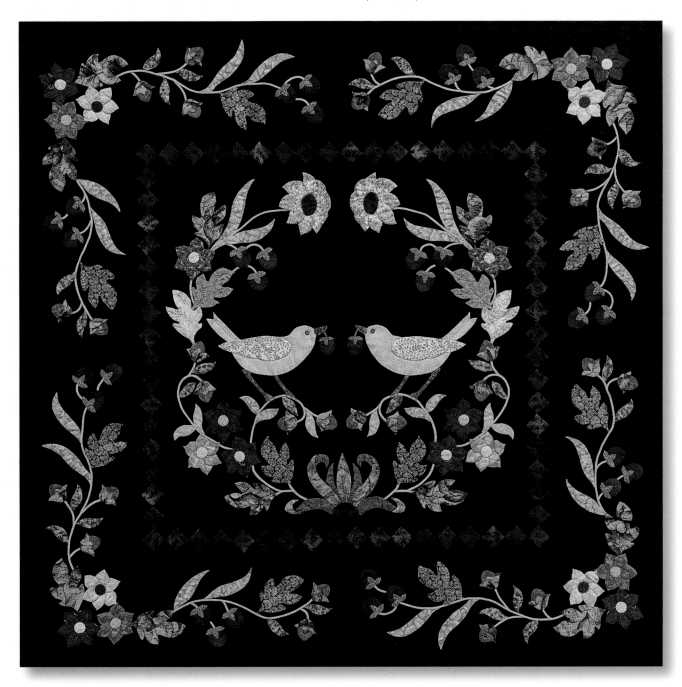

Appliquéd by Sheila Paprica, 2000, Burlington, Ontario, Canada. Sheila's impeccable workmanship and her choice of a tone-on-tone black background print give this quilt great visual impact. Hand quilted by Ermy Akers.

FABRICS

(42" wide after prewashing, unless otherwise indicated)

- 2¼ yds. black tone-on-tone print for center block, diamond border, appliqué border, and binding
- 1 fat quarter tone-on-tone gold for large flowers
- Assorted fat quarters gold, red, and pink print for small flowers
- Assorted contrasting scraps for flower centers
- 1 fat quarter each of 2 tone-on-tone red prints for strawberries and diamond border
- 1 fat quarter each of 2 prints in different shades of gold for birds
- 1 scrap dark gold print for beaks and legs
- 1 scrap dark gray print for eyes
- 1 fat quarter each of 6 or 7 assorted green prints for stems and leaves
- 1½ yds. 60"-wide fabric for backing and casing

CUTTING

From the black tone-on-tone fabric, cut:
- 1 square, 24½" x 24½", for center block
- 4 border strips, each 2" x 29", for diamond border. Cut on lengthwise grain from the fabric left beside the center block.
- 4 strips, each 7½" x 44", for appliqué border
- 5 strips, each 2¼" x 44", for binding

From the appliqué fabrics, prepare:
- the appliqué pieces shown on pages 57–62 and 63–66

From one of the tone-on-tone red prints, prepare:
- 68 square pieces for diamond border (use the pattern on page 63)

From the backing fabric, cut:
- 1 square, 46" x 46", for backing
- 1 strip, 8½" x 42", for casing

STRAWBERRY SEASON CENTER BLOCK

1. Prepare and stitch the Strawberry Season center block, referring to the placement diagram on page 56, the patterns on pages 57–62, the instructions for "Freezer Paper Appliqué" on page 10, and "Preparing Narrow Bias Stems" on page 12.

2. If desired, use a satin stitch to embroider thorns on the stems near the large flowers, referring to the instructions for "Embroidery Stitches" on page 15.

ADDING THE BORDERS
Diamond Border

1. Referring to "Freezer Paper Appliqué" on page 10 and the diamond border square template on page 63, stitch 16 red print squares onto each of 2 black print diamond border strips so that the side points of 2 squares meet at the center, as shown in the diagram below. The top and bottom points of the stitched squares should lie exactly ¼" in from the long cut edges of the border strips.

 NOTE: *The diagonal measurement of each square in the diamond border is 1½". Keep this measurement accurate in your stitched squares, so that the diamond border strips will fit onto the center block.*

Center of border strip

2. Sew these 2 diamond border strips onto the top and bottom of the center block, referring to the quilt diagram on page 56. Trim the ends of the border strips even with the center block.

 NOTE: *Make sure that there is an accurate ¼" seam allowance remaining at each end of these border strips after you trim them so that the squares on the remaining 2 diamond border strips will be correctly positioned. Press the seam allowances toward the center block.*

3. Stitch 18 red print squares onto the remaining 2 black print diamond border strips.

4. Sew these diamond border strips to the sides of the quilt top in the same manner as for the first 2 diamond border strips, referring to the quilt diagram at right. Press the seam allowances toward the center block.

Outer Border

1. Prepare and stitch the outer border strips, referring to the diagram, the patterns on pages 63–66, and the instructions for "Freezer Paper Appliqué" on page 10. Wait to appliqué the corner flowers and leaves until after the outer border strips are sewn onto the quilt.

2. Sew the outer border strips to the quilt top, referring to "Borders with Mitered Corners" on page 19. Press the border seam allowances toward the outer border strips. Press the corner seam allowances open.

3. Stitch the corner flowers and leaves at each corner of the outer border.

QUILTING AND FINISHING

1. Press the completed quilt top and trim any long threads.

2. Using a yardstick, mark diagonal crosshatch lines on the Strawberry Season center block, using the squares on the diamond border as your guide.

3. Layer and baste the backing, batting, and quilt top, referring to the instructions for "Basting the Layers" on page 21.

4. Outline-quilt ⅛" outside all the appliqué shapes and along the edge of the squares in the diamond border. Quilt along the marked diagonal crosshatch lines.

5. To fill in the remaining background areas on the border, echo-quilt lines spaced at ½" intervals around the appliqué border shapes.

6. Bind the quilt, referring to "Attaching the Binding" on page 21.

7. Make a label and hanging sleeve, referring to "Adding a Label" on page 22 and to "Attaching a Hanging Sleeve" on page 23.

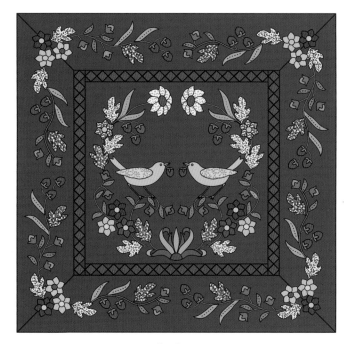

Quilt Diagram

PLACEMENT DIAGRAM FOR CENTER BLOCK

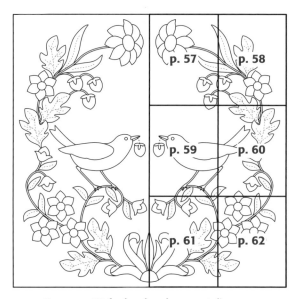

See page 63 for border placement diagram.

⑤ French knot

····· Stem stitch

▨ Satin stitch

--- Quilting stitch

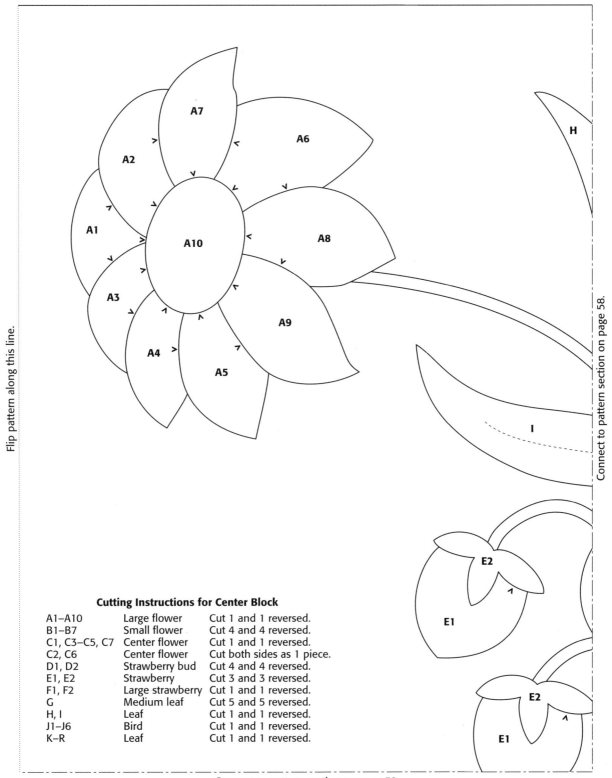

Flip pattern along this line.

Connect to pattern section on page 58.

Cutting Instructions for Center Block

A1–A10	Large flower	Cut 1 and 1 reversed.
B1–B7	Small flower	Cut 4 and 4 reversed.
C1, C3–C5, C7	Center flower	Cut 1 and 1 reversed.
C2, C6	Center flower	Cut both sides as 1 piece.
D1, D2	Strawberry bud	Cut 4 and 4 reversed.
E1, E2	Strawberry	Cut 3 and 3 reversed.
F1, F2	Large strawberry	Cut 1 and 1 reversed.
G	Medium leaf	Cut 5 and 5 reversed.
H, I	Leaf	Cut 1 and 1 reversed.
J1–J6	Bird	Cut 1 and 1 reversed.
K–R	Leaf	Cut 1 and 1 reversed.

Connect to pattern section on page 59.

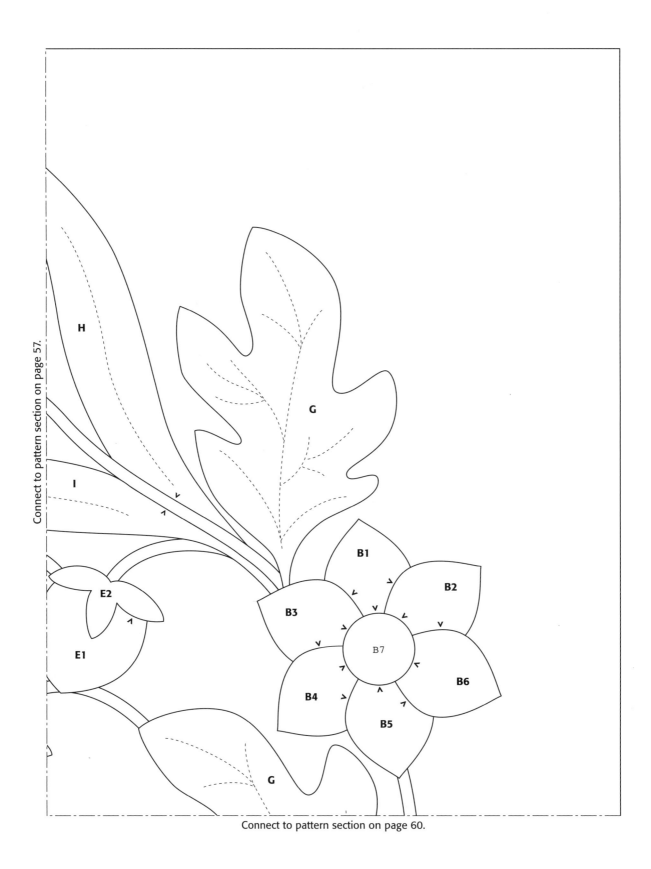

Connect to pattern section on page 57.

H

G

I

E2

E1

B1

B2

B3

B7

B6

B4

B5

G

Connect to pattern section on page 60.

Connect to pattern section on page 57.

Flip pattern along this line.

Connect to pattern section on page 60.

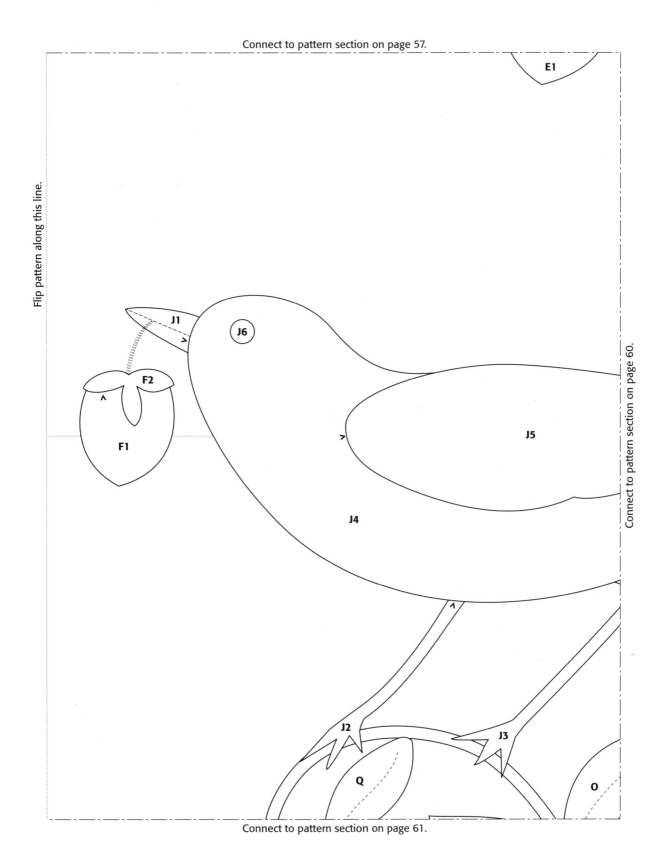

E1

J1

J6

F2

F1

J5

J4

J2

Q

J3

O

Connect to pattern section on page 61.

Connect to pattern section on page 58.

Connect to pattern section on page 59.

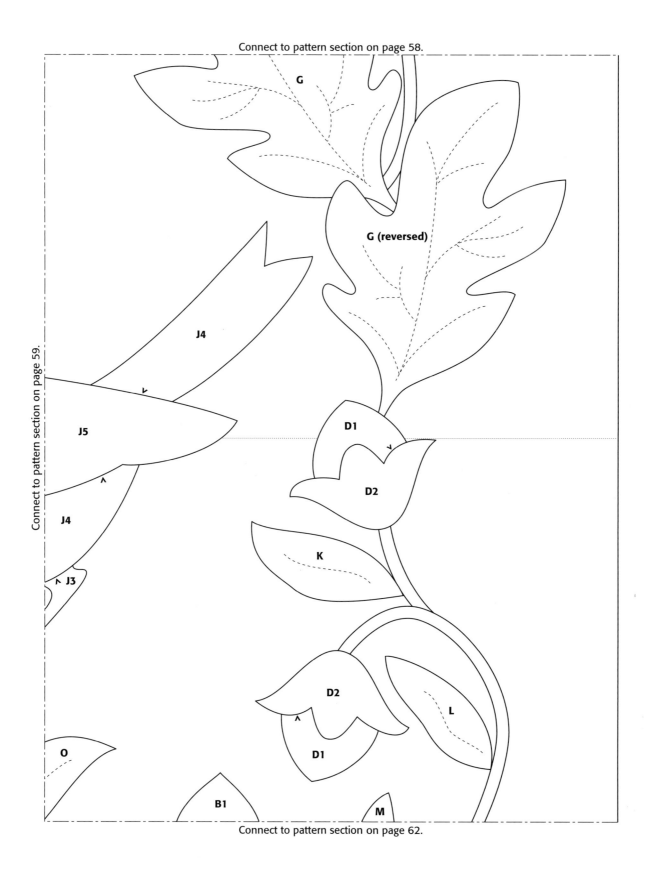

G

G (reversed)

J4

J5

J4

^ J3

D1

D2

K

D2

L

O

D1

B1

M

Connect to pattern section on page 62.

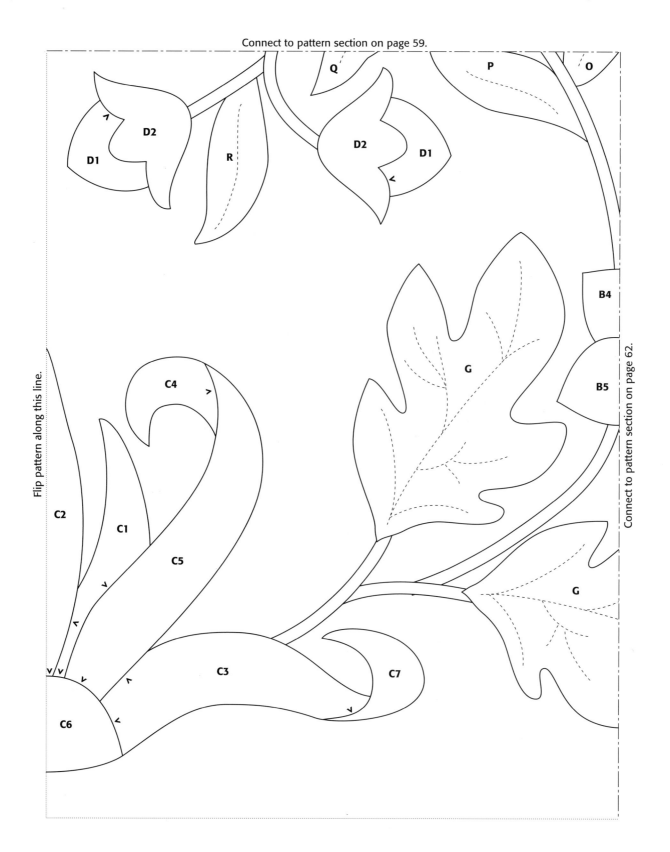

Connect to pattern section on page 59.

Flip pattern along this line.

Connect to pattern section on page 62.

Q

P

O

D2

D1

R

D2

D1

B4

B5

C4

C2

C1

C5

G

G

C6

C3

C7

Connect to pattern section on page 60.

Connect to pattern section on page 61.

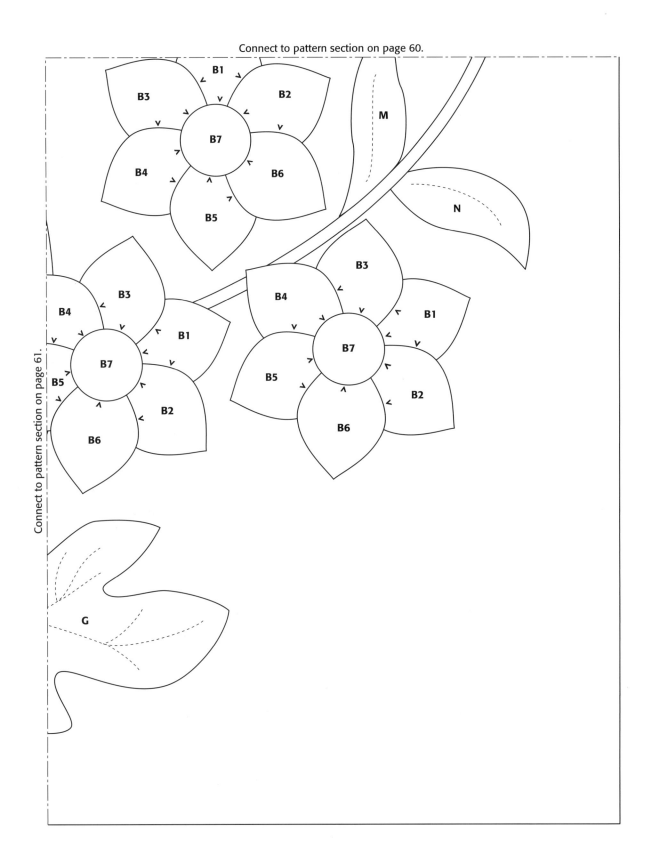

Cutting Instructions for Outer Border

B1–B7	Small flower	Cut 12 and 12 reversed.
D1, D2	Strawberry bud	Cut 20.
E1, E2	Strawberry	Cut 24.
S	Leaf	Cut 1 and 1 reversed.
T	Leaf	Cut 8 and 8 reversed.
U	Leaf	Cut 1 and 1 reversed.
V	Leaf	Cut 10 and 10 reversed.

Appliqué Template Pattern

¼" seam allowance

Diamond Border Square
Cut 68

← straight of grain →

Placement Diagram for Outer Border

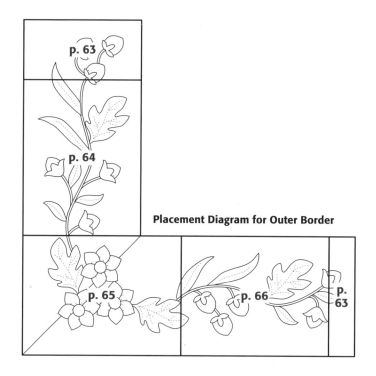

Flip pattern along this line.

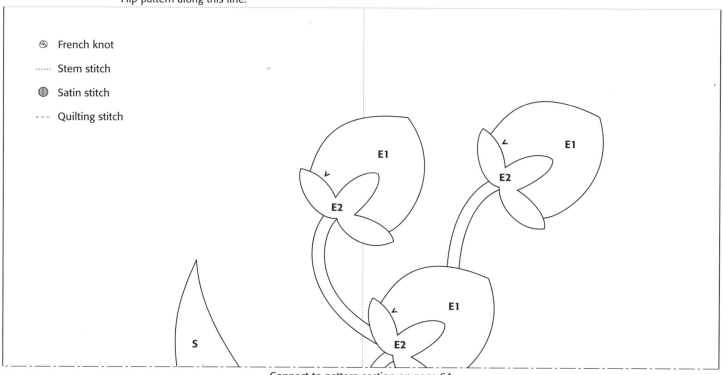

⑤ French knot

····· Stem stitch

▥ Satin stitch

--- Quilting stitch

Connect to pattern section on page 64.

Connect to pattern section on page 66.

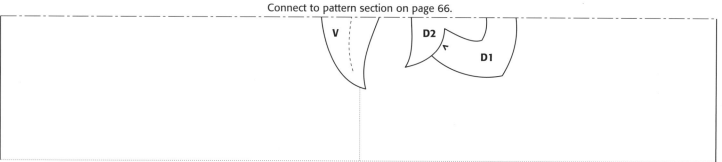

Flip pattern along this line.

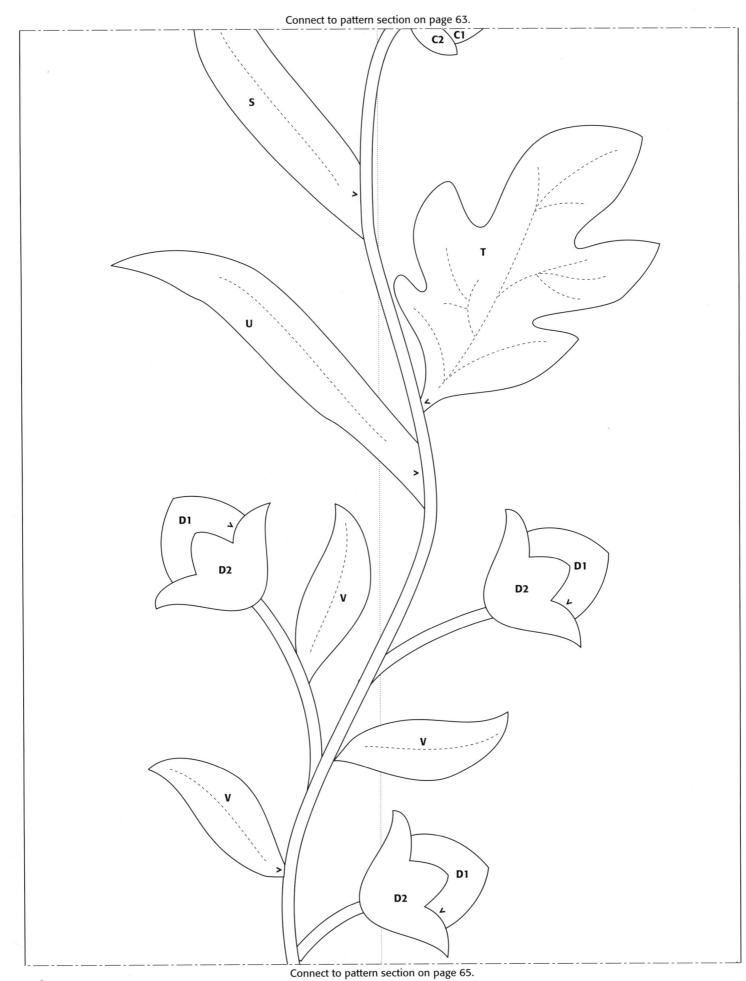

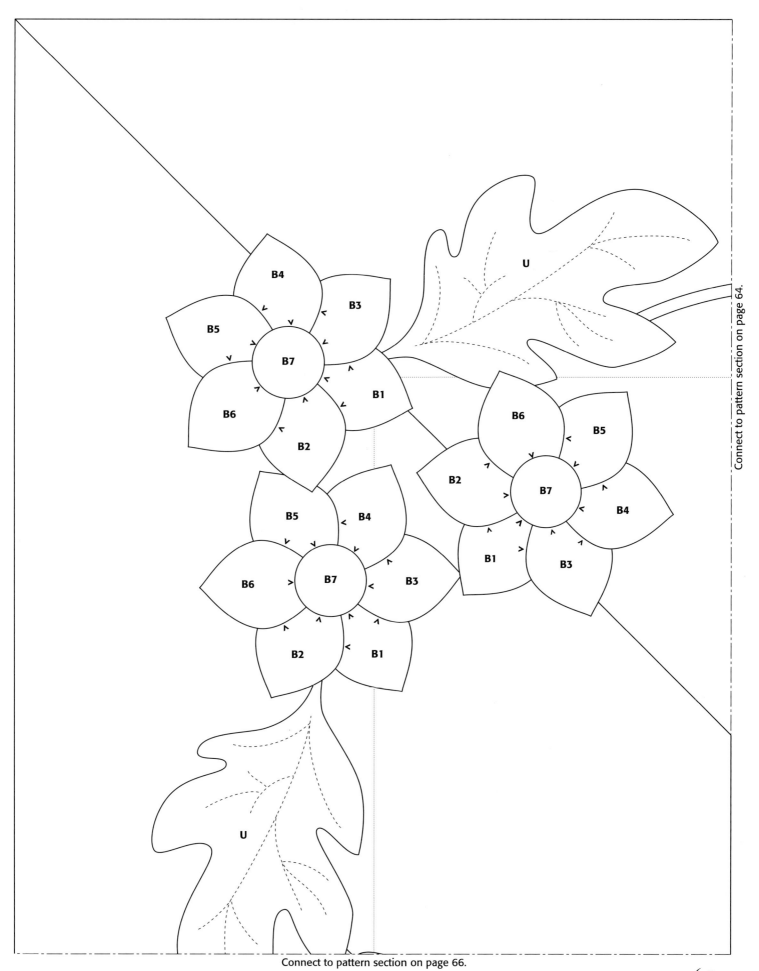

Connect to pattern section on page 64.

Connect to pattern section on page 66.

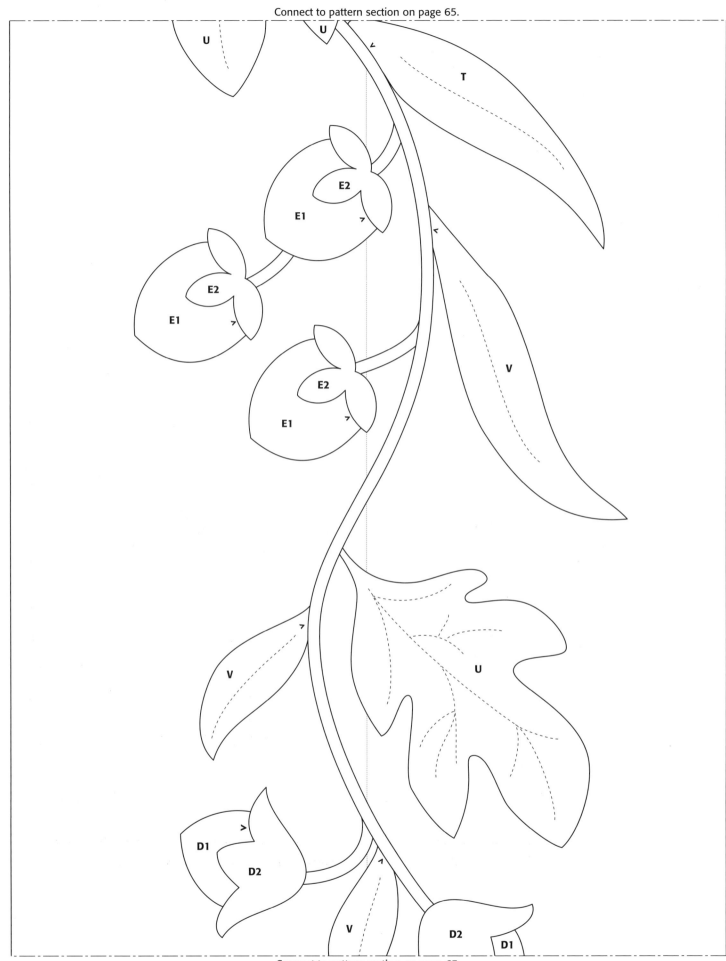

SPRINGTIME WALL HANGING

FINISHED SIZE: 52" X 52"

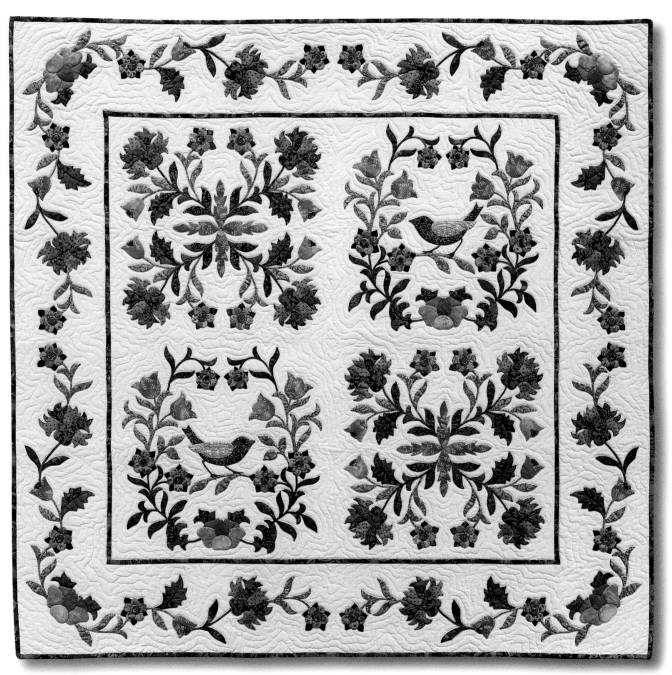

Appliquéd by Rosemary Makhan, 2000, Burlington, Ontario, Canada, with last-minute help from good friends Betty Decent, Karen L'Ami, Ruth Landon, Trudy Nicholls, and Sheila Paprica. Machine quilted by Rosemary Makhan.

FABRICS

(42" wide after prewashing, unless otherwise indicated)

- 2¾ yds. tone-on-tone ecru print for Springtime blocks and appliqué border
- 1 fat quarter each of 5 shades of green for stems and leaves
- 1 fat eighth each of 2 shades of blue for birds
- 1 fat quarter each of 3 shades of blue for large flowers
- 1 fat quarter each of 2 to 4 shades of gold for small and smallest flowers
- 1 contrasting fat eighth rust for small and smallest flower centers
- 1 fat quarter each of 6 tangerine prints for roses and tulips
- Small scrap navy for eyes
- Small scrap gold for beaks
- ¾ yd. blue print for contrast piping and binding
- 2 yds. 60"-wide fabric for backing and casing

CUTTING

From the tone-on-tone ecru print, cut:
- 4 squares, each 18½" x 18½", for Springtime blocks
- 4 strips *from the length of the fabric*, each 8½" x 54", for appliqué border

From the appliqué fabrics, prepare:
- the appliqué pieces shown on pages 70–79

NOTE: *In this quilt, the letter designations on the pattern pieces are* not *interchangeable between the 2 blocks and border.*

From the blue print, cut:
- 4 strips, each 1¼" x 42", for piping
- 6 strips, each 2¼" x 42", for binding

From the backing fabric, cut:
- 1 square, 56" x 56", for backing
- 1 strip, 8½" x 52", for casing

SPRINGTIME BLOCKS I AND II

1. Prepare and stitch 2 of Springtime block I and 2 of Springtime block II, referring to the placement diagrams on page 69, the patterns on pages 70–75, the instructions for "Freezer Paper Appliqué" on page 10, and "Preparing Narrow Bias Stems" on page 12.

2. Sew the 4 Springtime blocks I and II together in 2 horizontal rows, alternating positions, as shown in the diagram below. Sew the horizontal rows together to complete the quilt center.

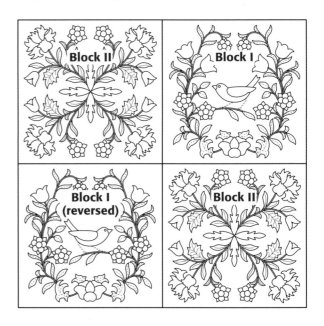

ADDING THE APPLIQUÉ BORDER

1. Prepare and stitch the 4 appliqué border strips, referring to the border placement diagram on page 76, the patterns on pages 76–79, the instructions for "Freezer Paper Appliqué" on page 10, and "Preparing Narrow Bias Stems" on page 12. Do not appliqué the corner flower and leaves until after the appliqué border strips are stitched onto the quilt center.

2. Fold the 1¼" x 42" blue print piping strips in half

lengthwise so they are ⅝" wide. Press these strips, making sure that the cut edges are aligned along the entire length of each strip.

3. Pin a blue print piping strip to each appliqué border strip, matching the centers of each piece and aligning the cut edges. Appliqué the folded edge of each piping strip in place on the appliqué border strip. After the appliqué is complete, press the appliqué border strips.

4. Sew the appliqué border strips onto the quilt center, referring to "Borders with Mitered Corners" on page 19. Press the seam allowances toward the appliqué border strips.

5. Stitch the corner flowers and their leaves at each corner of the appliqué border.

QUILTING AND FINISHING

1. Press the completed quilt top and trim any long threads.

2. Layer and baste the backing, batting, and quilt top, referring to the instructions for "Basting the Layers" on page 21.

3. Outline-quilt ⅛" around all of the appliqué shapes in Springtime blocks I and II and in the appliqué border. Continue echo-quilting lines at ½" intervals, until the background areas are filled.

4. Bind the quilt, referring to "Attaching the Binding" on page 21.

5. Make a label and hanging sleeve, referring to "Adding a Label" on page 22 and to "Attaching a Hanging Sleeve" on page 23.

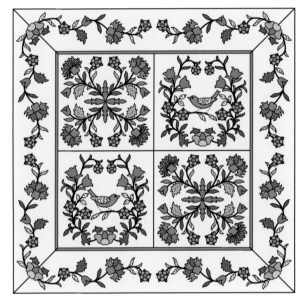

Quilt Diagram

PLACEMENT DIAGRAMS FOR BLOCKS

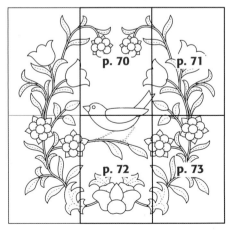

Springtime Block I

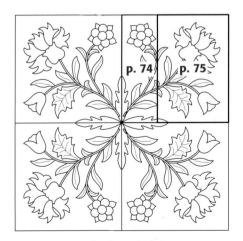

Springtime Block II

See page 76 for border placement diagram.

Cutting Instructions for 1 Springtime Block I

A1–A11	Small flower	Cut 1 and 1 reversed.
B1–B11	Large flower	Cut 2 and 2 reversed.
C1–C3	Rose	Cut 1 and 1 reversed.
C4, C5	Rose	Cut both sides as 1 piece.
D1–D4	Bird	Cut 1.
E	Tulip	Cut 2 and 2 reversed.
F–Z	Leaf	Cut 1 and 1 reversed.
AA–EE	Leaf	Cut 1 and 1 reversed.
FF, GG	Leaf	Cut 1.

⊜ French knot

⋯⋯ Stem stitch

▦ Satin stitch

--- Quilting stitch

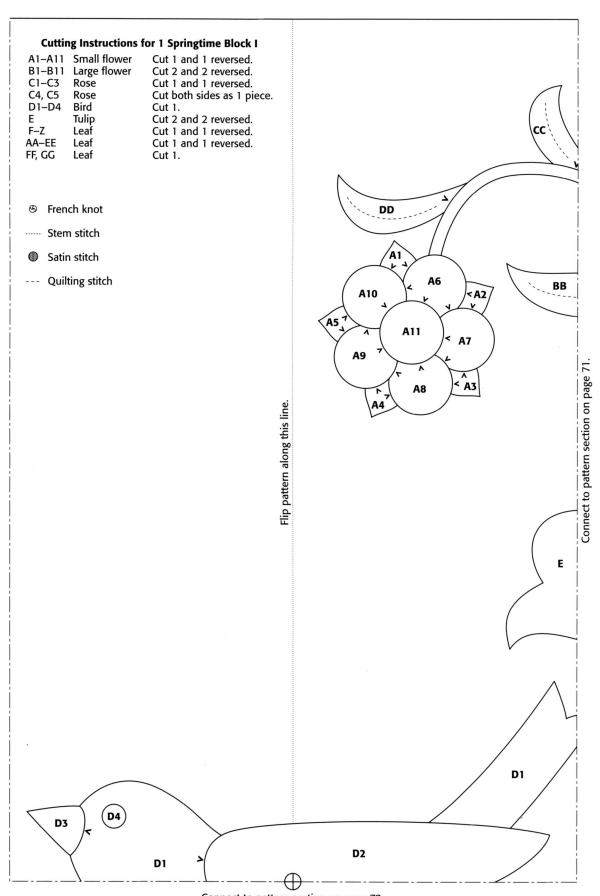

Flip pattern along this line.

Connect to pattern section on page 71.

Connect to pattern section on page 72.

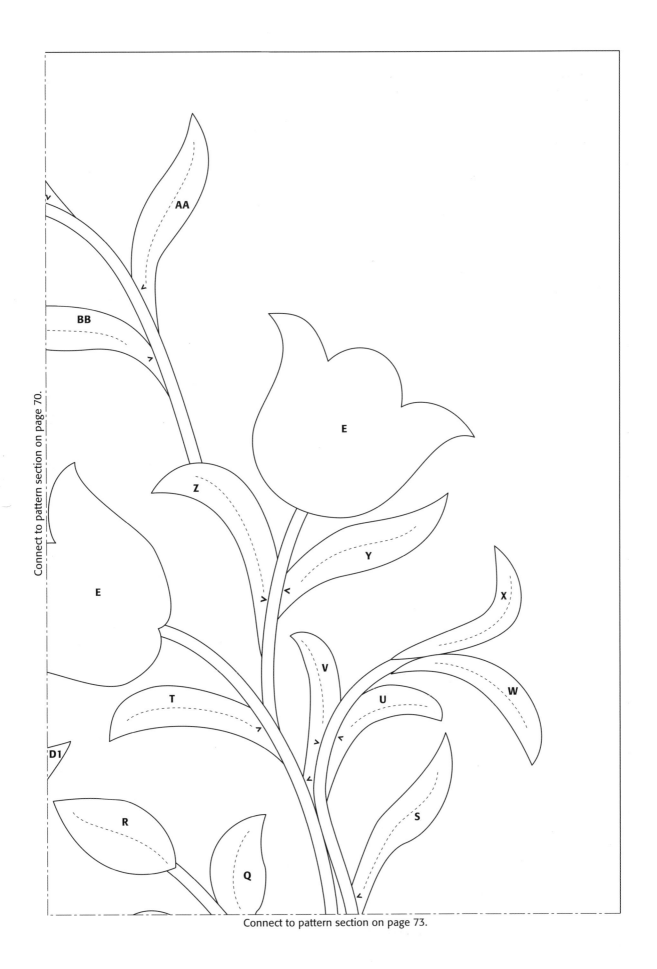

Connect to pattern section on page 70.

Connect to pattern section on page 73.

Connect to pattern section on page 70.

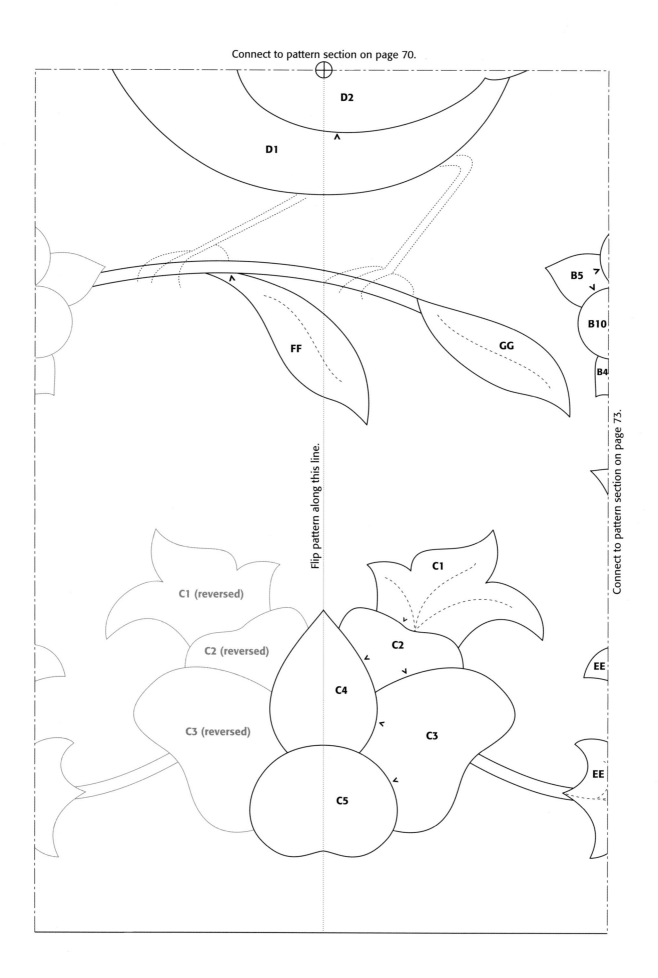

Connect to pattern section on page 73.

Flip pattern along this line.

D2

D1

B5

B10

B4

FF

GG

C1 (reversed)

C2 (reversed)

C3 (reversed)

C1

C2

C4

C3

C5

EE

EE

Connect to pattern section on page 71.

Connect to pattern section on page 72.

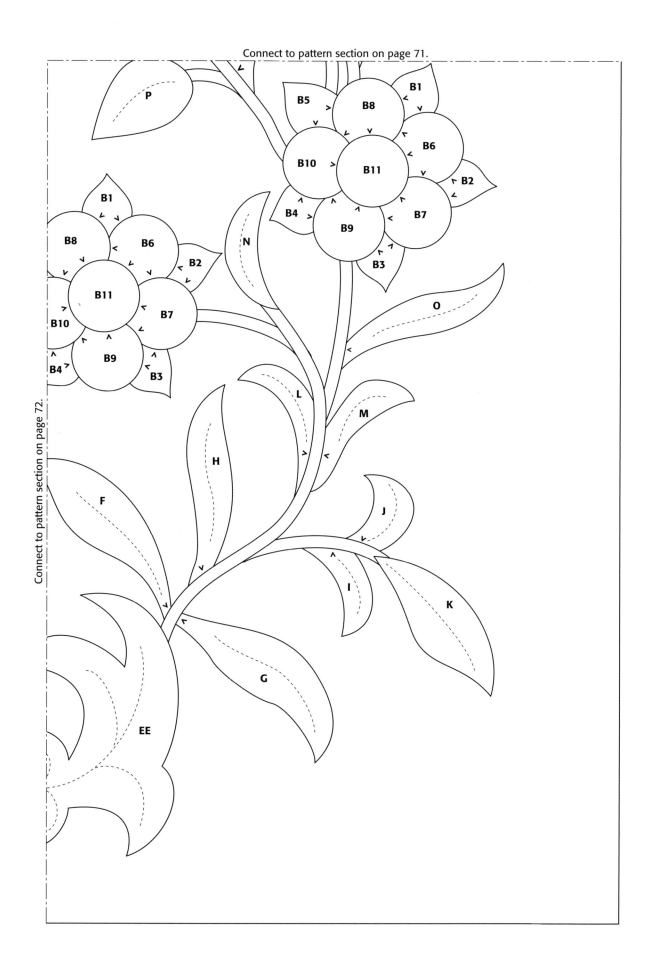

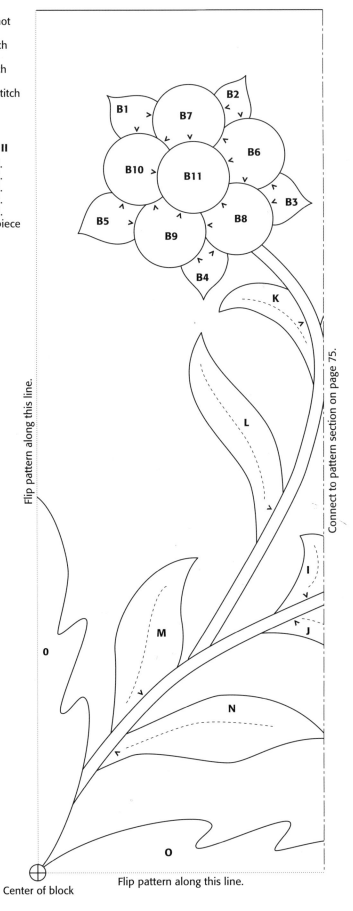

⟳ French knot

····· Stem stitch

▥ Satin stitch

--- Quilting stitch

Cutting Instructions for 1 Springtime Block II

A1–A6	Large flower	Cut 2 and 2 reversed.
B1–B11	Small flower	Cut 2 and 2 reversed.
C1, C2	Tulip	Cut 2 and 2 reversed.
D	Large leaf	Cut 2 and 2 reversed.
E–N	Leaf	Cut 2 and 2 reversed.
O	Center leaf	Cut both sides as 1 piece (4 total).

Flip pattern along this line.

Connect to pattern section on page 75.

Center of block

Flip pattern along this line.

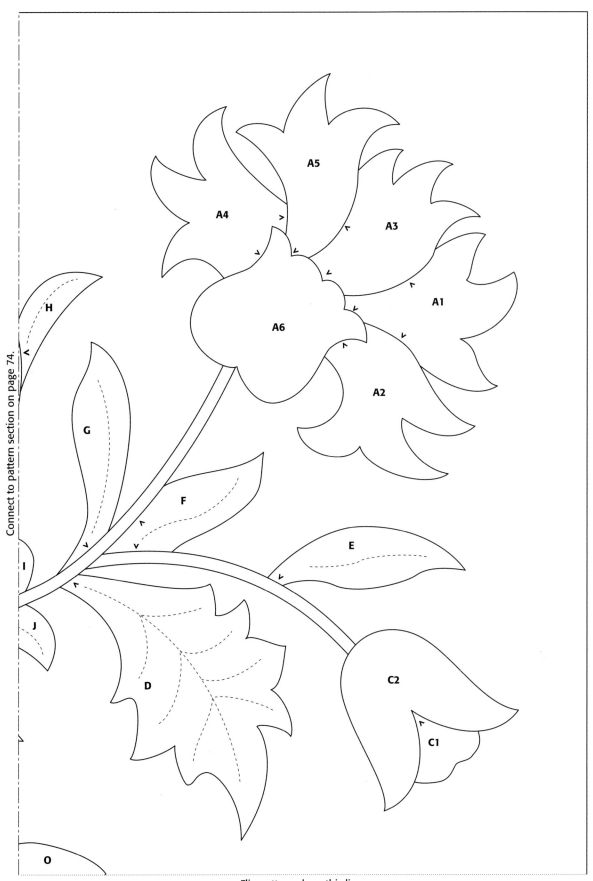

Connect to pattern section on page 74.

Flip pattern along this line.

Cutting Instructions for Border

A1–A6	Large flower	Cut 4 and 4 reversed.
B1–B11	Small flower	Cut 16.
C1, C2	Tulip	Cut 4 and 4 reversed.
D1–D3	Corner rose	Cut 4 and 4 reversed.
D4, D5	Corner rose	Cut both sides as 1 piece (4 total).
E–P	Leaf	Cut 4 and 4 reversed.

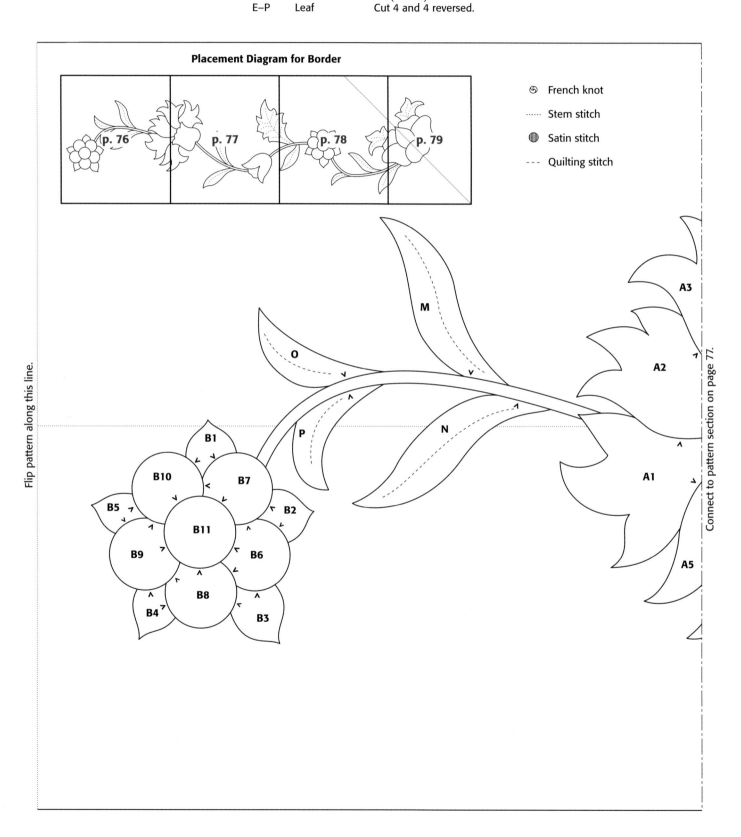

Placement Diagram for Border

p. 76 p. 77 p. 78 p. 79

⑤ French knot

····· Stem stitch

▥ Satin stitch

--- Quilting stitch

Flip pattern along this line.

Connect to pattern section on page 77.

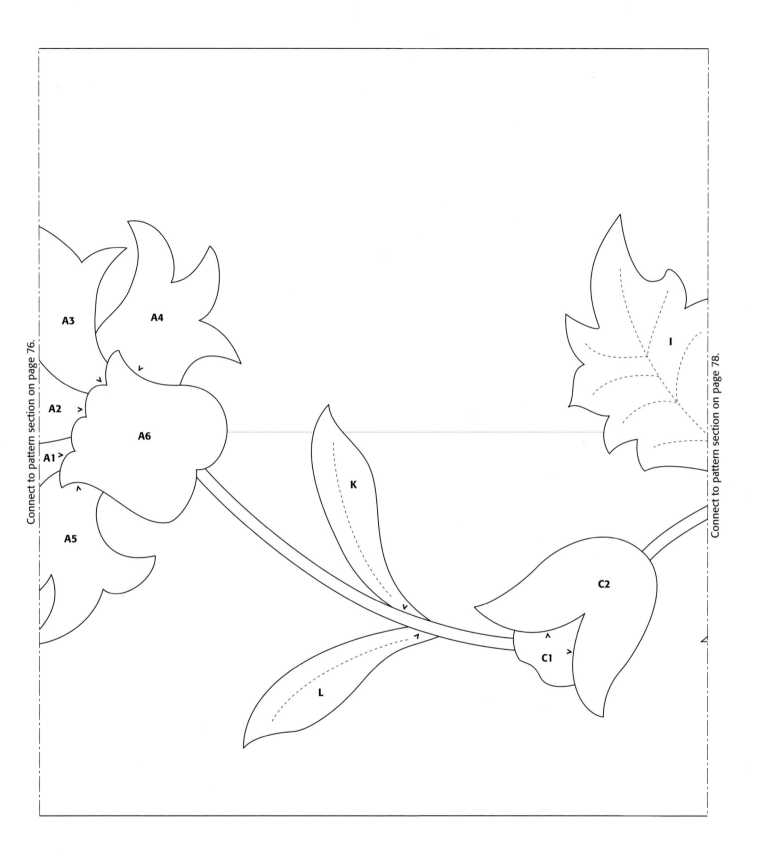

Connect to pattern section on page 76.

Connect to pattern section on page 78.

A3

A4

A2

A6

A1

A5

I

K

L

C2

C1

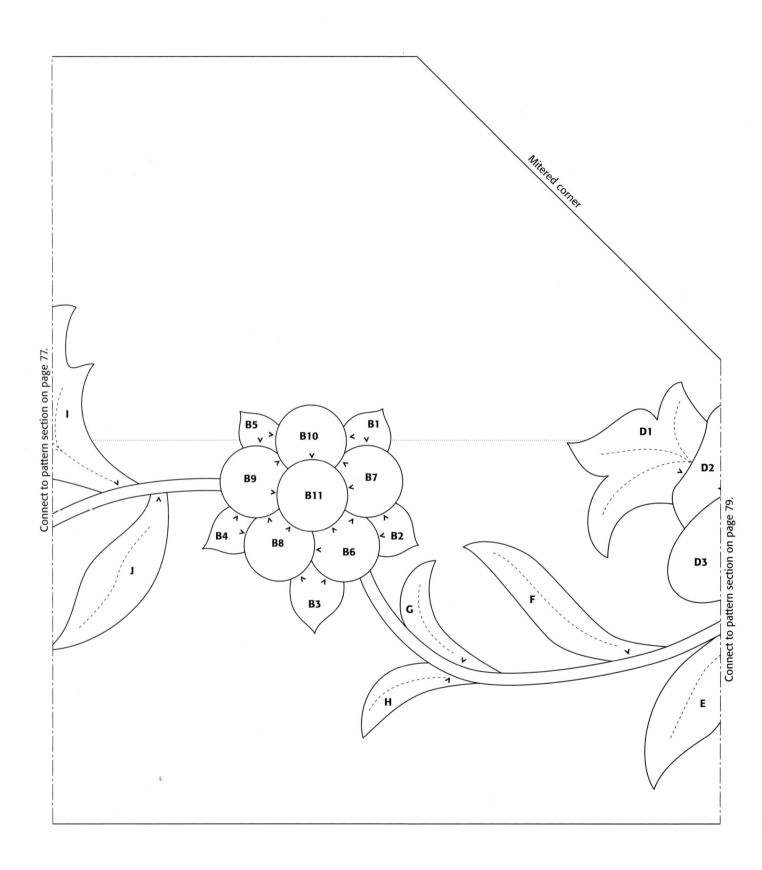

Connect to pattern section on page 77.

Connect to pattern section on page 79.

Mitered corner

I

B5 B1

B10

D1

B9 B7 D2

B11

B4 B2 D3

B8 B6

B3 F

G

J H E

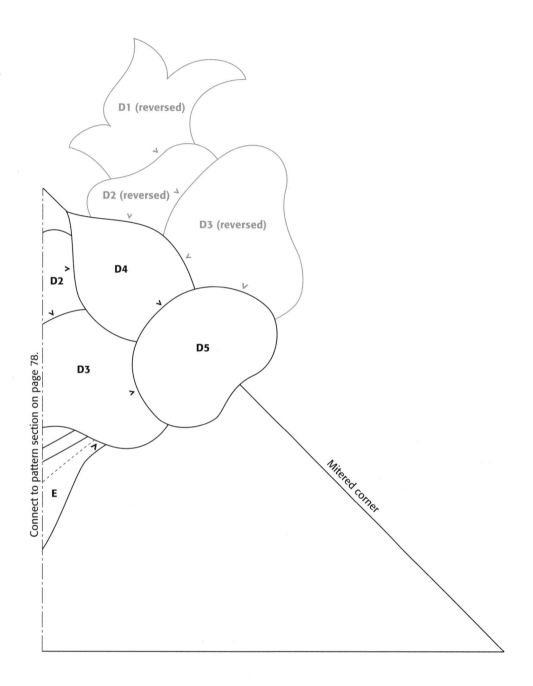

D1 (reversed)

D2 (reversed)

D3 (reversed)

D2

D4

D3

D5

E

Connect to pattern section on page 78.

Mitered corner

BIBLIOGRAPHY

Carlson, Elizabeth Hamby. *Small Wonders: Tiny Treasures in Patchwork & Appliqué.* Bothell, Washington: Martingale & Company, 1999.

Cox, Dorothy M. *Practical Home Needlecraft in Pictures.* Long Acre, London: Odhams Press Ltd., 1948.

Dietrich, Mimi and Roxi Eppler. *The Easy Art of Appliqué: Techniques for Hand, Machine, and Fusible Appliqué.* Bothell, Washington: Martingale & Company, 1994.

Gillow, Norah. *William Morris: Designs and Patterns.* London: Bracken Books, 1988.

Kimball, Jeana. *Loving Stitches: A Guide to Fine Hand Quilting.* Bothell, Washington: Martingale & Company, 1992.

Lochnan, Katharine A., Douglas E. Schoenherr and Carole Silver. *The Earthly Paradise: Arts and Crafts by William Morris and His Circle from Canadian Collections.* Toronto, Ontario: Key Porter Books Limited, 1993.

Makhan, Rosemary. *Rose Sampler Supreme.* Bothell, Washington: Martingale & Company, 1999.

Sommer, Robin Langley and David Rago, eds. *The Arts and Crafts Movement.* New Jersey: Chartwell Books Inc., 1995.

Swain, Gabrielle. *Appliqué in Bloom.* Bothell, Washington: Martingale & Company, 1994.

The William Morris Society. www.ccny.cuny.edu/wmorris/morris.html#Morris Society

Zaczek, Iain. *Essential William Morris.* Bath, England: Parragon, 1999.

ABOUT THE AUTHOR

ROSEMARY MAKHAN grew up in Nova Scotia, Canada, where she learned the basics of quiltmaking from her mother. Her love of sewing and fabric led her to major in home economics at Nova Scotia Teachers College and at Acadia University. She taught high school family studies for several years.

Her interest in quiltmaking was rekindled when she made a baby quilt for her daughter, Candice, who likes to tell her friends that, if it weren't for her, her mother probably wouldn't have begun her quiltmaking career.

Rosemary taught adult education classes, becoming the founding president of the Halton Quilters Guild in 1977. She continues to teach many quiltmaking classes and workshops and enjoys the special fellowship and inspiration that come from working with quilters.

A traditional quiltmaker, Rosemary loves appliqué and makes many pieced quilts as well. She especially loves sampler quilts that are based on a theme, such as her Biblical Blocks, Samplings from the Sea, and Make Mine Country quilts. Often, the quilts she makes are her own design. If they are not, she changes or adds something to make them distinctive. She has created many patterns, including the popular Woodland Creature Collector Series, printed under her pattern label, "Quilts by Rosemary."

Each fall, Rosemary helps conduct a "Quilting in the Country" retreat for quilters in the picturesque Ontario countryside. She now lives in Burlington, Ontario, Canada, with her husband, Chris. They have two children, Candice and Kenneth.